Graphic Thought Facility

Zoë Ryan
The Art Institute of Chicago / Yale University Press
A+D SERIES

A+D SERIES

Graphic Thought Facility has been published in conjunction with an exhibition of the same title organized by and presented at the Art Institute of Chicago from March 27 to August 17, 2008.

The exhibition and publication were made possible by the generous support of the Fellows and Benefactors of the Architecture and Design Department, Celia and David Hilliard Fund, the Architecture & Design Society, British Airways, and the British Council.

This is a publication of the Ernest R. Graham Study Center for Architectural Drawing at the Art Institute of Chicago.

© 2008 The Art Institute of Chicago

All rights reserved. No part of this publication may be reproduced, transmitted, or utilized in any form or by any means, electronic or mechanical, including photocopy, digital recording, or any other information storage and retrieval system, without prior written permission from the Publications Department of the Art Institute of Chicago, except by a reviewer, who may quote brief passages in a review.

First edition
Printed in the United States of America

Library of Congress Control Number: 2008920988
ISBN: 978-0-300-14060-6

Published by
The Art Institute of Chicago
111 South Michigan Avenue
Chicago, Illinois 60603-6404
www.artic.edu

Distributed by
Yale University Press
302 Temple Street
P.O. Box 209040
New Haven, Connecticut 06520-9040
www.yalebooks.com

Produced by the Publications Department of the Art Institute of Chicago,
Susan F. Rossen, Executive Director
Edited by Robert V. Sharp,
Director of Publications, and
Elizabeth Stepina, Special Projects Editor
Production by Carolyn Heidrich,
Production Coordinator, and
Kate Kotan, Production Assistant
Photography research by Joseph Mohan,
Photography Editor
Series design by 2x4, New York
Book design by Jeff Wonderland,
Associate Director, Department of Graphic Design
Typeface: Plantin Light
Separations by Professional Graphics, Rockford, Illinois
Printing and binding by Classic Color, Broadview, Illinois

Photography Credits

Unless otherwise noted below, all images are courtesy of Graphic Thought Facility.

p. 11: Courtesy of Neville Brody, Research Studios
p. 12: Photographs by Joseph Mohan, with special thanks to Bill Mondi
p. 13: Courtesy of Why Not Associates
p. 14: Courtesy of Paul Elliman
p. 15 top: Courtesy of Florent Morellet
p. 15 bottom: Peter Cook © Archigram 1965, courtesy Archigram Archives
p. 16: Courtesy of Ron Arad
p. 17 left: Courtesy of Vitra
p. 17 right: Courtesy of Michael Marriott
p. 18: Courtesy of Tord Boontje
pp. 40, 82–83, 89: Photographs by Francis Ware
p. 94: Photograph by Angela Moore

Previous books in the A+D Series
Douglas Garofalo (2006)
Young Chicago (2007)
Figuration in Contemporary Design (2007)

Contents

Foreword
James Cuno 4

Graphic Thought Facility: Resourceful Design
Zoë Ryan 7

Foreword

Graphic Thought Facility is the fourth installment in the Art Institute of Chicago's A+D Series. Organized by Zoë Ryan, Neville Bryan Curator of Design, the exhibition and catalogue explore the work of the London-based design studio Graphic Thought Facility (GTF). Zoë Ryan's insightful essay provides a comprehensive overview of GTF's output over the last decade, positioning the firm's work within the history of contemporary design. The projects undertaken by GTF draw on a range of influences, breaking with past practices grounded in minimalist design in an effort to create inventive and expressive graphic solutions that speak to the time in which they were made. *Graphic Thought Facility* also marks the first exhibition and publication to feature a single design firm at the museum and illustrates the increased scope of the Art Institute's newly expanded Architecture and Design Department.

The exhibition and publication were made possible by the generous support of the Fellows and Benefactors of the Architecture and Design Department, Celia and David Hilliard Fund, the Architecture & Design Society, British Airways, and the British Council.

On behalf of Zoë Ryan, I would like to express our immense gratitude to the members of Graphic Thought Facility, in particular to directors Paul Neale, Andy Stevens, and Huw Morgan for their commitment to this project and their stellar exhibition design, as well as to Roland Brauchli, Philippa Brook, Robbie Mahoney, Mike Montgomery, and Simon Kinneir. We would also like to acknowledge the Carnegie Museum of Art, David McKendrick, Phaidon Press, Rizzoli Publications, and the Royal Jelly Factory for the loan of exhibited items.

Special thanks go to the members of the Architecture and Design Department: Joseph Rosa, Chair and Curator of Architecture and Design; Lori Boyer, Exhibitions and Collections Manager; Titus

Dawson, Departmental Technician; Jennifer Breckner, Architecture & Design Society Coordinator; Judy Freeman, Senior Programming Consultant; the department's inspired volunteers, Kay Manning, Phil Kennedy, and Harvey Choldin; and its diligent interns, Tara Flippin, Sara Jacobson, Kurt Schleicher, Chalida Tangsurat, Sarah Forbes, and especially Julia van den Hout. I would also like to acknowledge members of the Publications Department for their work on the catalogue: Robert V. Sharp, Carolyn Heidrich, Kate Kotan, Joseph Mohan, and Elizabeth Stepina. Appreciation goes to Jeff Wonderland, who designed the catalogue. The Museum Registration Department under Mary Solt, in particular Darrell Green and Jennifer Oberhauser, was invaluable in organizing the transportation of exhibition items. Bernice Chu and Markus Dohner provided expert advice and assistance during the planning of the installation and the execution process. We would like to acknowledge the legal department of the museum, in particular Executive Vice President, General Counsel, and Corporate Secretary Julia E. Getzels and Maria Simon, Associate General Counsel. Gratitude is extended to several members of our Conservation staff—Harriet Stratis, Christine M. Fabian, Kristi Dahm, Emily Heye, and Barbara Hall—for giving careful attention to each exhibition object. We are most thankful to John Molini and Craig Cox and the shipping and installation staff of Museum Registration for their care in handling and presenting the works of art. We are also grateful to William Caddick and Thomas Barnes of the Department of Physical Plant; Larry Johnson, Carpenter Shop Foreman; and their staff for the care they have given to this exhibition space.

Special appreciation also goes to Carrie Heinonen, Erin Hogan, Chai Lee, and Jocelin E. Shalom for their promotion of the exhibition. I wish to express our gratitude to Associate Vice President Michelle Lehrman-Jenness and her staff in the Department of Protection Services for their excellence in overseeing all our exhibitions. Finally, my heartfelt appreciation goes to the staff in the Office of the President and Director: Dorothy Schroeder, Associate Director for Exhibitions and Museum Administration; Jeanne Ladd, Vice President for Museum Finance; and Dawn Koster, Museum Fiscal Affairs Coordinator.

James Cuno
President and Eloise W. Martin Director
The Art Institute of Chicago

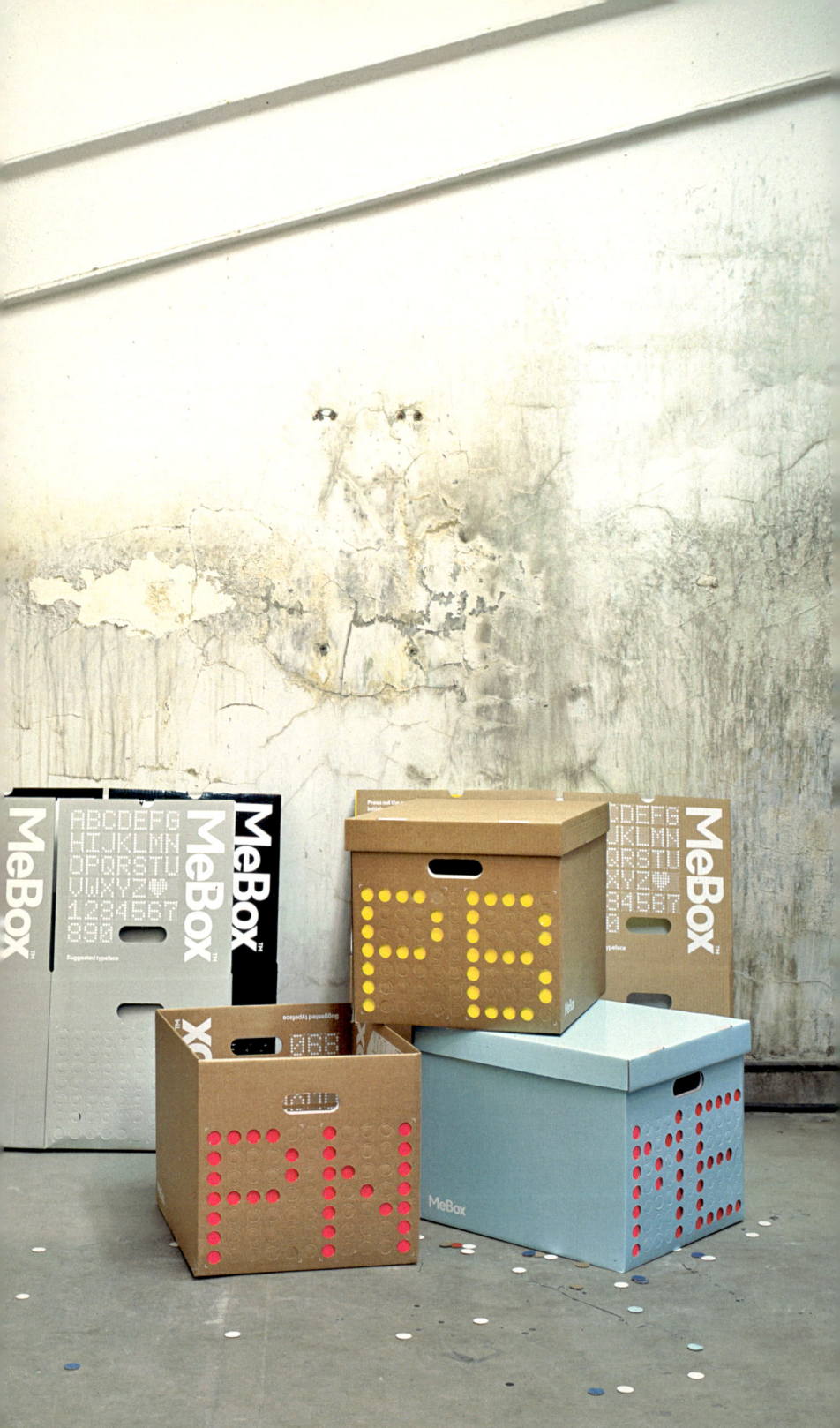

Graphic Thought Facility: Resourceful Design
by Zoë Ryan

Since the early 1990s, Graphic Thought Facility (GTF), a London-based graphic design studio under the direction of Paul Neale, Andy Stevens, and Huw Morgan, has been at the forefront of spearheading graphic design solutions centered on the expressive power of image and typography, as well as a desire to push the boundaries with new materials and new production methods. Incorporating both handcrafted and industrial techniques, contemporary and historical references, humor, and multiple layers of meaning, their fluent design process results in inventive solutions for clients ranging from fashion designers and artists to museums and corporations.

GTF's work signals a break from the past. Graphic design in the first half of the twentieth century was grounded in the tenets of clean, minimalist design based on pure geometries of form, as outlined by the Bauhaus, and in the postwar period, by the Ulm School of Design (Hochschule für Gestaltung Ulm), both of which had a significant influence on the development of modern graphics. What followed was an effort to institutionalize their principles and methods through the creation of house styles and corporate design programs that dissolved into overtly deterministic formulas—yielding, in the end, bland interpretations of these formerly fluid practices. Since the 1980s, however, designers have sought to move beyond previous ways of making in an effort to seek relevance to contemporary society through a confluence of approaches that break down old hierarchies of high and low and inspire original and significant graphic expressions. Independent graphic design studios have emerged that are generating an energetic exchange of ideas and processes, pushing graphic design into uncharted territories

Fig. 1 GTF, MeBox storage system, 2003.

with far-reaching influences across the fields of art and design. GTF's work speaks to this multifaceted approach. They generate tailor-made designs that respond to the cultural and historical context of a project, regardless of whether the assignment involves packaging, book design, exhibition graphics, or way-finding systems.

GTF was founded in 1990 by Paul Neale and Andy Stevens, who met in the late eighties while studying for master's degrees in communication art and design at the Royal College of Art (RCA) in London. They established the studio with Nigel Robinson (who left the practice in 1993). Huw Morgan joined the firm in 1996 and was made a principal in 2003. Citing British designers such as Derek Birdsall as early influences, the GTF members graduated from the RCA with an interest in non-conformist approaches to graphic design. The independent practice is well known in Europe for creating the brand identities of some of the bastions of British design. The Design Museum in London and Habitat, a popular retailer launched in 1964 by Terence Conran, are clients that GTF has worked with for many years. GTF is also responsible for designing the identity system for Frieze, London's major annual contemporary art fair, and the firm continues to create marketing materials, signage, and catalogues for this event. Another critical part of the studio's output is book design. Projects include monographs on the work of Ron Arad (Phaidon, 2004) and Tord Boontje (Rizzoli, 2006), and the exhibition catalogue for the 54th Carnegie International in 2003 at the Carnegie Museum of Art in Pittsburgh. Integrating special materials and print processes, GTF's publications are extraordinary objects in their own right. GTF works at the highest levels of production and theory, generating projects that have a resonance across contemporary design practices. Not limited to two-dimensional forms, the firm's work often takes on a further dimension when engaged at the scale of industrial design or architecture. Its output includes exhibition graphics for institutions such as the Victoria & Albert Museum and products for sale at Tate Britain's and Tate Modern's retail stores.

The studio favors a do-it-yourself aesthetic that began as a pragmatic response to the recession that hit Britain in the 1990s, but was equally a rejection of the slickly styled graphics that characterized much that was produced in the UK during the 1980s. A handmade quality based on the craft of graphic design defines the studio's work, which often engages unexpected juxtapositions between materials, production methods, typefaces, and visual languages in an effort to create original expressions.

Although straightforward in its approach, GTF is not afraid to design complex graphics with high levels of detail and is part of a new generation of designers forging a return to decoration. For GTF ornamentation is a multifaceted device that is best used to enrich inherent narratives within its work and to create projects that can be continuously reimagined. The studio's output is distinctive and displays its difference from other graphic design typologies.

Located on the second floor of a former industrial building in Exmouth Market in London, GTF's open-plan studio reflects the firm's informal design philosophy. Studio members sit at desks laid out in nonhierarchical arrangements across the main space. An adjacent area framed by a library of books, research materials, and neatly labeled box files of archived work functions as a conference room. A long table at its center is illuminated by Tom Dixon's Mirror Ball ceiling lights. Within this workshoplike setting, designers often switch seats and take up projects on another's computer or work together in small groups at a conference table or in front of displays pinned to the walls, illustrating a fluid approach that favors collaboration.

GTF understands graphic design as a communicating device and a means by which intellectual, cultural, and social questions are framed and explored. A particular typeface, the juxtaposition of image and text, the color palette, and the overall composition determine how we read and understand the world around us. Graphic designers have traditionally been defined as problem solvers, rather than authors.[1] Although the members of GTF work as designers in a conventional sense, creating work as a response to a client's brief, each project is approached with a new set of criteria, resulting in unique outcomes that differ from one project to the next. Their creative fingerprints are omnipresent in their work and define their graphic output. As design critic Rick Poynor has noted, "If 'graphic design' now strikes some designers and design-watchers as too rigid a term, this is partly because it sounds like a largely technical procedure, but particularly because it fails to suggest the expanded possibilities of contemporary visual culture."[2] Clients commission GTF knowing that its critical approach to the project will form an important part of the company's response to the brief.

GTF's exploratory and experimental method of visual communication, one that embraces hybrid forms and practices, stems from the time the founding principals spent at the Royal College of Art. The RCA is a dynamic learning environment that fosters the flow of ideas

across disciplines. Within the Department of Communication Art and Design, importance is placed on exploring new digital media without losing sight of traditional craft-based ones. It is the value placed on the handmade above the mass-produced and the significance given to process, materials, and technique that inspired the founders of GTF and provided them with the tools that have defined their own production.

Paul Neale still recalls spending much of his time at the RCA in the technical resources library researching new materials and production methods. Among the studio's early works is a poster that utilizes stamping foils. One of GTF's only pieces of promotional material, this poster employs foils with wood-grain or metallic blue "car-paint" finishes, as well as silkscreen and black letterpress type. The foils, typically found printed on packaging for electronics, are here taken out of context and used to create silhouettes of the figures of the three principals. The work has more in common with the types of graphics used in the music industry for posters marketing pop and rock bands than it does with traditional promotional items. "The poster was on one level very tongue-in-cheek and on another level quite a serious mission statement," explained Neale, asserting the studio's goal of appropriating materials and production methods to achieve unexpected results."[3]

GTF's design process is always highly involved, requiring rigorous research and collaborations with photographers, illustrators, manufacturers, and experienced printers. The principals keep their studio small and direct each project, overseeing all aspects in an effort to control the creative process and produce work that has a consistently high level of output. Their working style is aligned with graphic design practices such as Fletcher/Forbes/Gill, established in London in 1962 by Alan Fletcher, Colin Forbes, and Bob Gill. This firm set a standard for independent graphic design with clients such as Penguin, Pirelli, and Shell, and based its work on the thesis that "one visual problem has an infinite number of solutions; that many of them are valid; that solutions ought to derive from the subject matter; that the designer should therefore have no preconceived graphic style."[4]

Working almost half a century later, GTF has produced a portfolio of designs distinguished by the regard it pays to content, for each one of the firm's projects necessitates an individual response. The principals are not interested in developing a studio style but in creating work that engages a given set of conditions, restrictions, and needs, and that speaks to the time in which it was made.

GTF's earliest influences include the work of British graphic designers Malcolm Garrett and Peter Savile. The studio members cite designer Neville Brody, whose work for the music industry and at *The Face* magazine (where he was art director from 1981 to 1986) particularly appealed to them. Brody, who went on to art direct several other periodicals, including *Actuel*, *Arena*, and *The Observer* newspaper and magazine in London, attacked the visual formulas that were applied to commercial design and advocated for a more humanistic approach to graphic design, favoring handmade marks. His work at that time was characterized by free-floating graphics loosely held together by line, color, and hand-drawn typography (fig. 2). His uninhibited style borrowed references from the raw abandonment of 1960s punk graphics by designers such as Jamie Reid, known for making iconic album covers for the Sex Pistols (figs. 3–4). Poynor has asserted that graphic designers such as Brody held "a belief that design could be personal, that it could be aesthetically adventurous, and that it need not conform to the dated

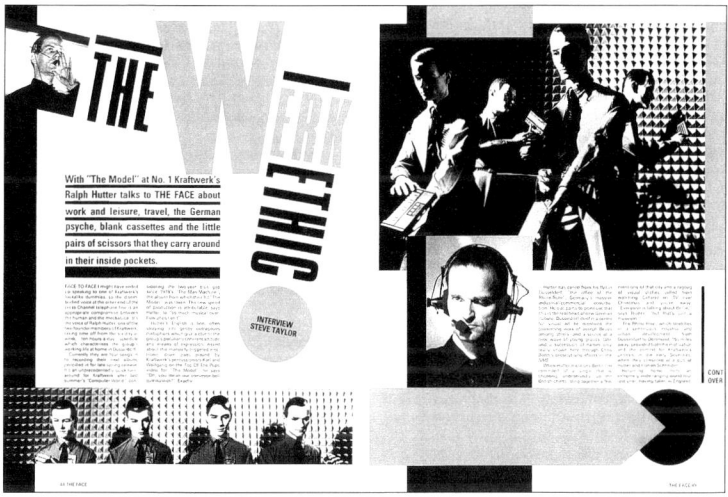

Fig. 2 Neville Brody, *The Face*, March 1982.

simplicities of the graphic idea, which they regarded as patronizing and dull."[5] Brody's work and that of his contemporaries gave rise to a new era of graphic design based on sensibilities that broke free from the restraints imposed by modernist teachings and practices.

New forms of creative expression utilizing handmade techniques were also a response to the social and political unrest in Britain in the 1980s and

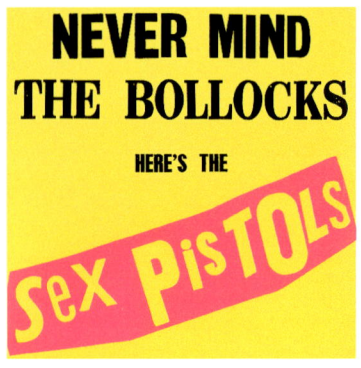 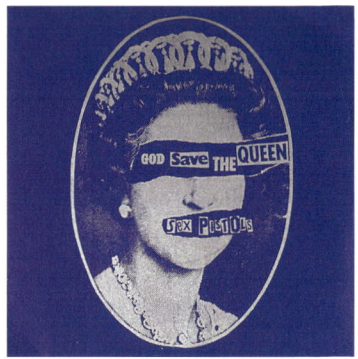

Figs. 3–4 Jamie Reid, album covers for *Never Mind the Bollocks* and *God Save the Queen* (both by the Sex Pistols), 1977.

the country's poor economic climate. Graphic designers were challenged to respond to changes in the social fabric of daily life through their work. Low-tech processes enabled them to create inventive graphic solutions with limited resources. They were also reacting to the introduction in 1984 of the Apple Macintosh computer, the first mouse-driven computer with a graphical user interface: designers could now see on the computer screen the exact layout or image that would ultimately be printed. This advancement liberated the field and provided a level of flexibility that encouraged designers to consider more complex solutions to graphic design and more integrated relationships between text and image. Eager to flex their muscles with this technology, a new generation began to focus on the possibilities of designing using the computer, and celebrated the explosion of excessive and stylized graphic design languages. Just as architect Robert Venturi had challenged architects in 1966 to develop a new type of architecture that would reflect modern experience through elements that are hybrid, messy, and ambiguous, graphic designers were motivated by their desire to create multilayered communications that captured the tone of contemporary life.[6] Andy Altmann and David Ellis graduated from the RCA in 1987, three years before the founders of GTF, and the two immediately set up Why Not Associates. Influenced by the new wave of complex graphics created using the computer, they generated advertising for British fashion designer Ted Baker and posters for cultural institutions such as the Institute of Contemporary Arts that have been described as "wild assemblages of letterforms, irregular shapes and stray rules colliding together and rushing apart" (fig. 5).[7] Through their compositions of imagery and text, Why Not Associates sought to stimulate an active engagement in their work.

This type of graphic design dominated the industry through the eighties and nineties, prompting the founders of GTF—who left college when this type of work was at its height—to seek alternative graphic languages

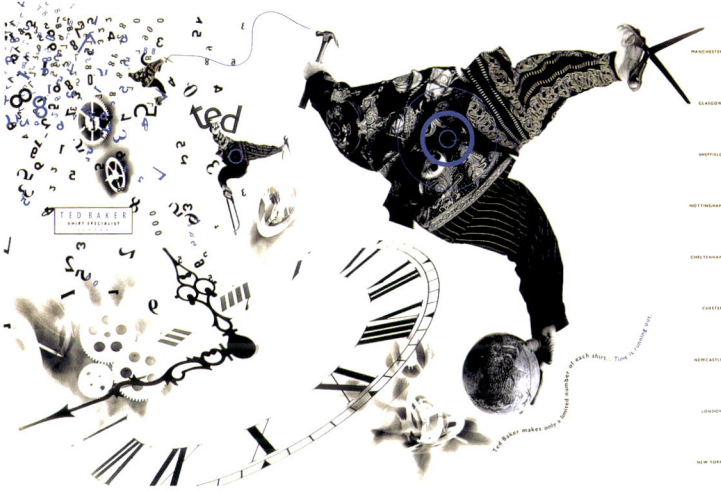

Fig. 5 Why Not Associates, advertisement for Ted Baker—Men's Wear, 1987–88.

in which the hand of the designer was more immediately legible than any high-tech means. Curator Claire Catterall has noted that a coterie of designers who did not have "a taste for unnecessary clamor and special effects," instead turned to "graphic realism," favoring work that returned to basics, emphasized the craft of graphic design, and placed importance on the content of a project to generate a design solution.[8]

Searching for an independent language that would distinguish their approach, GTF drew inspiration from the vernacular design being made by other contemporaries like Paul Elliman. A self-taught graphic designer, Elliman became known in the 1990s for his experimental projects utilizing found materials. Bits is a typeface he created from pieces of debris found on the roadside that he combined in different configurations to form each letter of the alphabet and then scanned into a computer and manipulated into a typographic system (fig. 6). Elliman explained that he "wanted to begin by establishing a very open relationship with different forms of language: figurative, expressive, associative."[9] Although his assembled objects can be read as a graphic system, as Elliman has noted, they defy "being regularized into a 'proper' typeface."[10] Other designers working along similar lines include such luminaries as Tibor Kalman, whose New York–based studio M&Co worked in the eighties and nineties

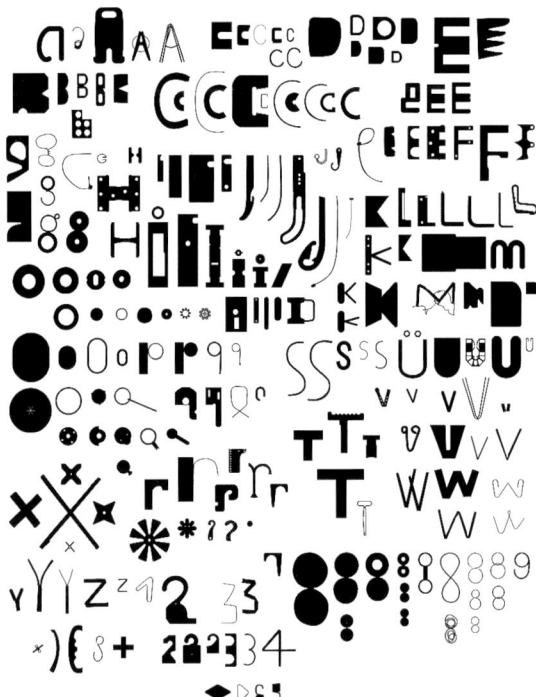

Fig. 6 Paul Elliman, Bits typeface, 1995.

with vernacular advertising and signage and bold typography to create the identity for Restaurant Florent in New York City (figs. 7–8), album covers for rock bands such as Talking Heads, and covers and editorials for *Colors*, a Benetton-sponsored magazine launched in 1990.

In addition to graphic designers, GTF members have cited architects and architectural firms as early influences. One of these, Archigram, the avant-garde group formed in London, created primarily hypothetical works on paper, printed in their own magazine of the same name, first published in 1961. Their designs were futurist, antiheroic, and proconsumerist, drawing inspiration from technology as a way to express new ideas about cities and urban development. Their principles are epitomized in Peter Cook's concept drawings for Plug-In City (1964–65), megastructures made to accommodate standardized components based on individual requirements (fig. 9). Just as Le Corbusier proposed a "machine for living," so Cook envisioned his own solution for high-rise dwelling. But Robert Venturi is probably the most well known figure to have expounded the virtues of hybrid approaches

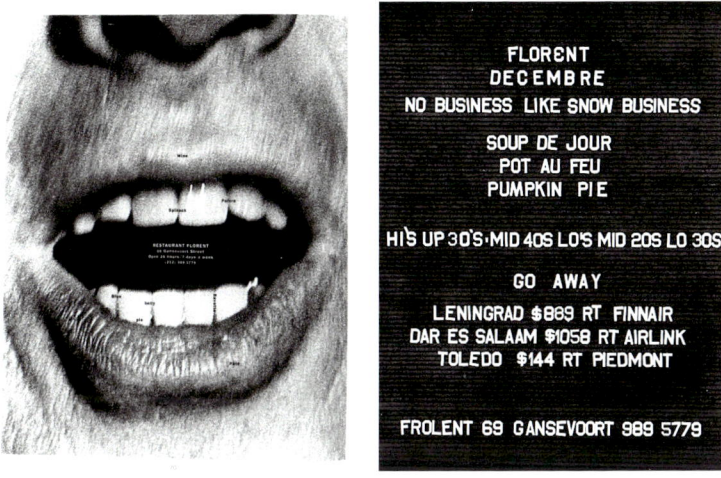

Figs. 7–8 M & Co, identity for Restaurant Florent, New York, 1985.

to architecture and vernacular form as a way to revitalize urban communities. In *Learning from Las Vegas* (1972), written with Denise Scott Brown and Steven Izenour, Venturi charged architects to study the ubiquitous signage of the Las Vegas strip to break free from modernism and instead introduce democratic, accessible design into the fabric of the built environment.

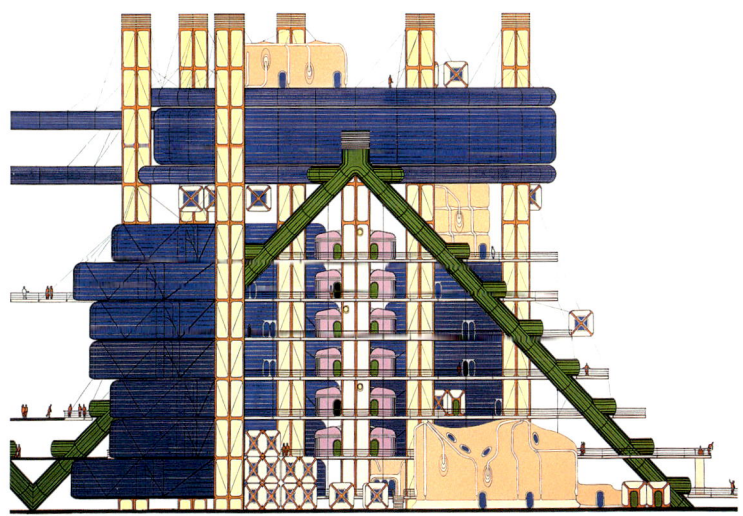

Fig. 9 Peter Cook for Archigram, Plug-In University Node, from Plug-In City, 1965.

These designers and others broke new ground for the generation that followed. They paved the way for an expanded range of aesthetic approaches and helped widen the definition of design as a cultural practice rather than simply a problem-solving tool.

Throughout the 1980s and early 1990s, a cluster of industrial designers hungry for experimentation and inhibited by the economic climate of London also began exploring new methods. Like the architects and graphic designers before them, these professionals were interested in developing independent creative expressions as a forum to stimulate dialogue about the world around them. Leading this initiative was the Israeli-born, London-based designer Ron Arad, who founded Creative Salvage in 1984 with Mark Brazier-Jones and Nick Jones. This loose-knit collective employed a scrap-yard aesthetic to their work, salvaging car seats and scaffolding to create sound systems and chairs that have an informal but immediate quality. Arad's early works include Rover Chair (1981), made from a Rover 200 car seat mounted on a frame of Kee Klamp scaffolding originally designed in the 1930s (fig. 10). Two years later he cast a discarded stereo in concrete, playing inventively with form and function (fig. 11). These works and others were shown at One Off, Arad's architectural design office/showroom, which opened in 1979 in Covent Garden (and later moved to Chalk Farm, London), along with works by such designers as Tom Dixon, Danny Lane, and Jasper Morrison. By combining original and preexisting objects into innovative constructions with new uses, designers were able to create an element of surprise and novelty that reawakened interest in previously discarded materials and forms.

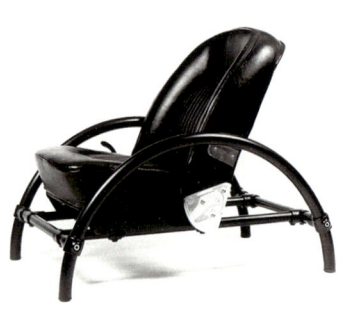 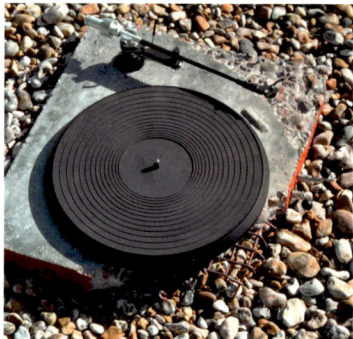

Figs. 10–11 Ron Arad, Rover Chair, 1981, and Concrete Stereo, 1983.

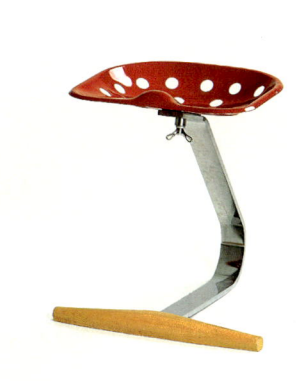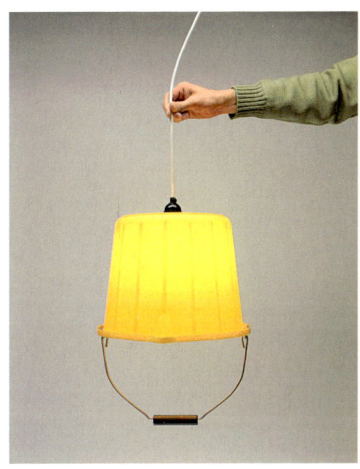

Fig. 12 Achille and Pier Giacomo Castiglioni, Mezzadro Stool, 1957.
Fig. 13 Michael Marriott, Bucket Light, 1995.

Practicality as well as theoretical or ideological imperatives drove interests in appropriation. This form of design has its roots in modern art and the readymades of Marcel Duchamp, such as *Bicycle Wheel* (1913), which consists of a bicycle wheel mounted to a kitchen stool. Later, Picasso incorporated a similar conceit in his work, creating *Head of a Bull* (1943) by joining a bicycle seat to a set of handlebars. It did not take long before design followed suit. In 1957 Achille and Pier Giacomo Castiglioni designed the Mezzadro Stool (fig. 12) by bolting a tractor seat to a chrome and wood base, and in the process, as curator Gareth Williams has recently noted, "legitimized the use of ready-mades and industrial components in design."[11]

The 1990s saw the continuation of this way of working. In 1995, for example, British designer Jane Atfield created shelving out of a wooden clothes horse by adding a canvas cover, while Michael Marriott made a lamp from a bulb shaded by an upended plastic bucket (fig. 13). In 1998 Dutch born Tord Boontje developed his Rough and Ready collection of furniture made from crude pieces of timber (fig. 14). He later summed up his approach during these years: "I find it hard to relate to the prevalent plastic slickness and preciousness. With this furniture I want to develop my ideas about objects we live with. Ideas about a utilitarian approach towards the environment we live in."[12] The response by these designers and others working along the same lines was a return to basics and a renewed involvement in vernacular design and craft techniques

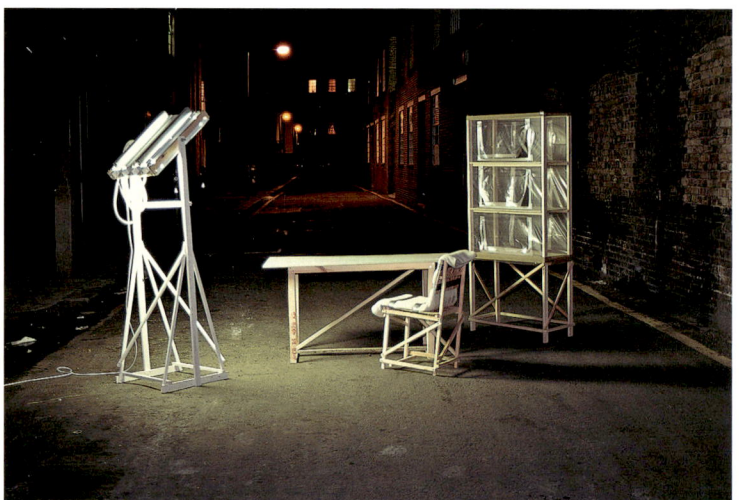

Fig. 14 Tord Boontje, Rough and Ready furniture collection, 1998.

rather than computer-led practices. Such analog processes provided a new internal logic to design and fostered an interest in the reuse of found materials and the decorative possibilities of the simplest shapes and substances.

CUSTOMIZED DESIGN

Royal College of Art
A do-it-yourself aesthetic and hands-on mentality are evident in GTF's early works, such as its design for the 1998/99 prospectus for the founding members' alma mater, the Royal College of Art. This seminal project called for an organizing principle that would reflect the diversity of each of the departments within the college, but portray them on equal terms. The solution was both pragmatic and a way to ensure creative freedom. GTF invited each department to select promotional materials such as newspaper clippings and magazine articles that best reflected its successes. These were photocopied and reproduced in black and white. The rough manner of the presentation extended to the cover image, which shows a collage of pages from the prospectus with bookmarks and Post-it notes. The prospectus could easily be mistaken for a student's sketchbook found in the art studios. The informal presentation was both a unifying device and a practical response to the restrictive budget. GTF purposefully kept costs low by printing in black and white and using crude reproductions, rather than generating new material, in order to be able to print the catalogue at a larger quantity for greater impact. In addition, it allocated a portion of the budget to creating a color section at the front of the publication. Rather than reproduce photographs of college life like those typically found in university promotional pieces, GTF hired Kam Tang, a recent graduate of the college, to develop a series of illustrations depicting aspects of the RCA that make it distinct from other colleges: the architecture of the buildings, the facilities for students, and the graduation ceremonies held at the Royal Albert Hall. Neale has commented that the illustrations allowed the firm more license to communicate a range of aspects about the college than photographs would have done.[13] An intricate assemblage of symbols, signs, objects, and words dance across one of Tang's double-page spreads. A blackboard, tools, a television, needles, balls of thread, a telegraph pole, a spoon, and various nuts, bolts, springs, and coils can be identified among the potpourri of objects that are scattered across the page, demonstrating the breadth of art and design practice at the college. On another page, a colorful bar graph, rendered by Tang, analyzes the number of students over five years who had found work after graduation.

GTF deliberately set up juxtapositions between the images, texts, and illustrations in the RCA prospectus, and employed different weights

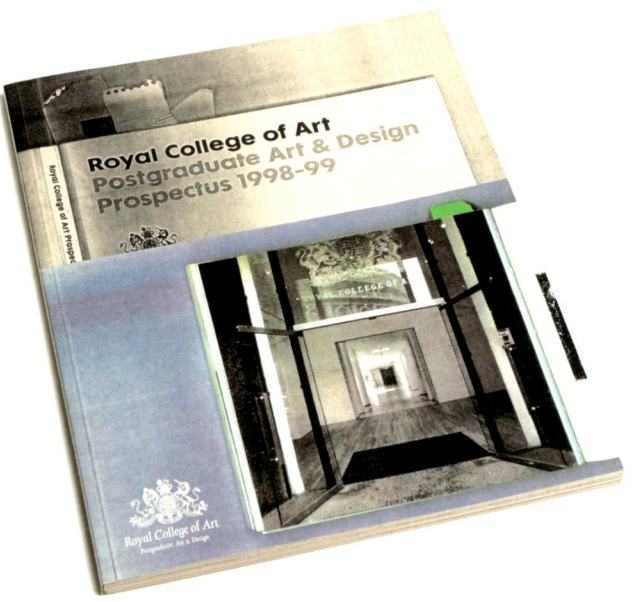
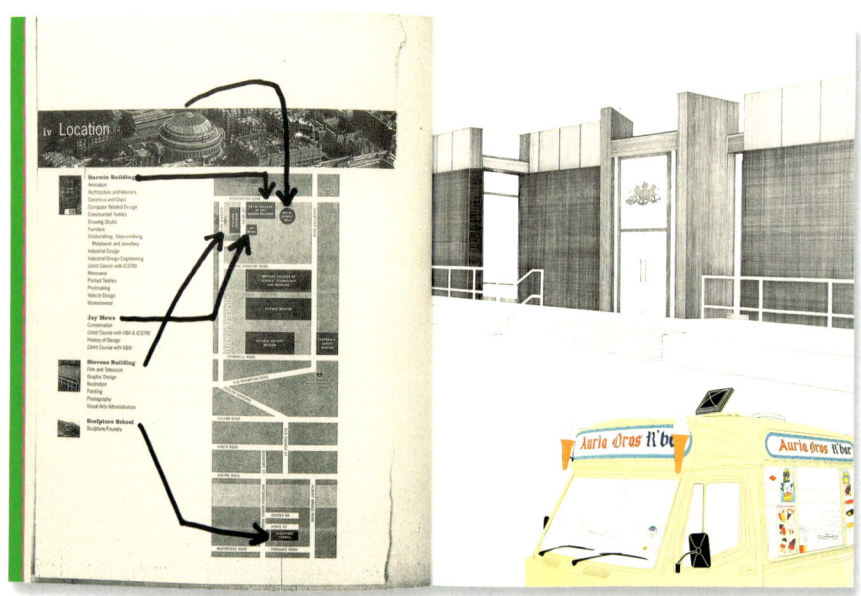

GTF, with illustrations by Kam Tang, prospectus for
the Royal College of Art, London, 1998.

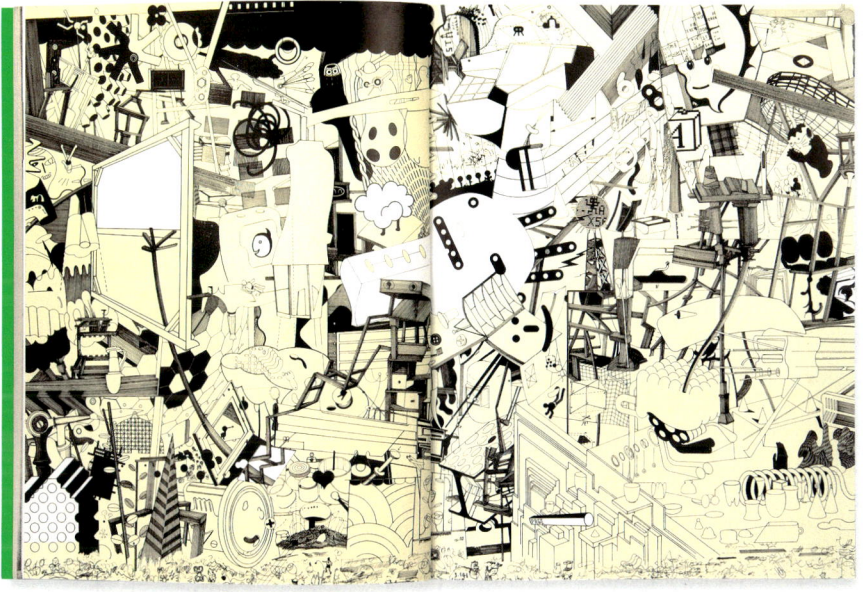

22
Vehicle Design

As we stand on the edge of the 21st century and look back over the last 100 years it is clear that, of all this century's many innovations, it is the car that has had the greatest and most profound social impact.

Certainly for the last 50 years all our lives, in the developed world at least, have been shaped by the enormous opportunities that relatively unbridled personal mobility affords. And that freedom has singled not just our society, our economy and our expectations, but also, fundamentally, our environment.

As we look to the next century it is clear that freedom of personal mobility carries with it enormous responsibility to society as a whole, to the developing world, to the environment and to future generations.

Our ability to influence the quality of our society and our environment, for better or worse, has never been greater. Never before have our individual choices carried with them such enormous social responsibilities; never before has it been so vital to challenge conventional ideologies and to search for new visions and new solutions.

Vehicle Design has been studied at the Royal College of Art since 1967. The course evolved from within the course of Industrial Design and has continued to share mutual aspirations regarding the design process and the academic development of postgraduate designers appropriate for Vehicle Design activities of the future.

The course was originally established to provide a broader spectrum of designers and stylists for the international automotive design industry. The course, supported by the major automotive manufacturers, undertakes to define, analyse and create future vehicle concepts. The course has an enviable employment record and its graduates are represented in almost all the international automotive design studios. In recent years the course has attracted various students who have requested a course of study related to other forms of transportation. Some of these applicants have been accepted onto the course with successful results. Therefore consideration and encouragement is extended to applicants with interests in marine, rail and aviation design.

Whilst the professional dimension achieved on the course will be enhanced, increasing emphasis will be directed towards promoting individual design aspirations, and a wider selection of graduate intake from both science and the arts will be encouraged.

The objectives of the course are to provide a wider range of career potential, as well as identifying, developing and promoting radical vehicle design concepts. Conditions will usually have graduated from Industrial design schools. However, consideration is extended to graduates with a first degree

The course aims to provide, influence and inspire the international transport and vehicle design profession and to integrate the fields of transport and vehicle design. It aims to produce professional, independent graduate designers possessing high levels of creative intelligence, occupational confidence and sophisticated critical analysis who are equipped to practise as professional designers with a finely honed awareness of their moral and social responsibilities.

Vehicle Design is not a technical course of study – the design language of the course is centred on cultural and contextual issues and the students are expected to introduce social, metaphorical and olfactory elements to their projects.

The course has a policy of continuous assessment tutorial groups dominate the first year. Individual tutorials continue for the duration of the programme.

Year One, Term 1

The Introductory project of the course requests the new intake to illustrate a self-selected vehicle of special design interest. They are then required to verbally deconstruct the design language of the vehicle and critically appraise the strengths and weaknesses of the design. The second phase is to manipulate those ingredients and components of the design he have been considered detrimental. All members of the first year group participate in the reviews. This is an important project to establishes the fundamental design methodology of the course.

The second project of this term is the Alex Poplers workshop, this is an experimental, inspirational event, involving visits to various art galleries aimed at interpreting the art values, in an automotive context.

The final project of this term is the design of a leisure vehicle inspired by the individually selected 'name' of the vehicle. It is a broad-based project involving design by metaphor. This project will involve the creation of a small-scale model.

Year One, Term 2

There will be one major project for this term. It will involve the co-operation of a major automotive manufacturer and the issue of analogue versus digital design. That is, each student will have the opportunity to evaluate the importance of traditional studio skills in conjunction with the new electronic tools (computers and video animations).

At the beginning of this term all students must pass a formal interim Examination to be allowed to proceed to the first year. During the interim Examination all students will be expected to introduce their initial design briefs related to their first-year project(s). The remainder of this term is dedicated to the seven and conceptual studies related to the second year programme. Students are advised to associate their research is sympathy with the requirements of the School of automotive design which must be delivered at the end of the second year (see Studio and College-wide Programme, page 66).

During this term first-year students are encouraged to visit the graduating students in the completion of their models and the setting up of the final-year Show.

Year Two, Terms 1 and 2

These two terms are entirely devoted to the design evolution of the final-year projects. All final-year students will have an informal meeting with their External Examiner at the end of Term 1 and a Part 1 Examination will take place in the middle of Term 2. This Examination will include work from previous terms and the in-progress work related to the Master's crash.

Year Two, Term 3

The Part 2 (Final) Examination occurs towards the end of this term and is centred on the Master's degree projects.

Staff and Resources

The staff are entirely devoted to the design evolution of vehicle design. In most aspects of vehicle design, Visiting Lecturers are invited from a variety of automotive design companies and informed individuals. All students should possess a workable knowledge of illustrative skills and understanding of how statement is formed. Conditions for Vehicle Design should possess a portfolio which demonstrates a broad range of visual design skills related to general design and automotive work.

Individual tutorial requirements

Candidates must have completed or be in the final year of a first degree of art and design, or in engineering. The International status of the course encourages overseas applications. All applicants should possess a scheme devoted of illustrative skills and understanding of how statement is formed. Conditions for Vehicle Design should possess a portfolio which demonstrates a broad range of visual design skills related to general design and automotive work.

NEWS OF THE WORLD 30.6.96

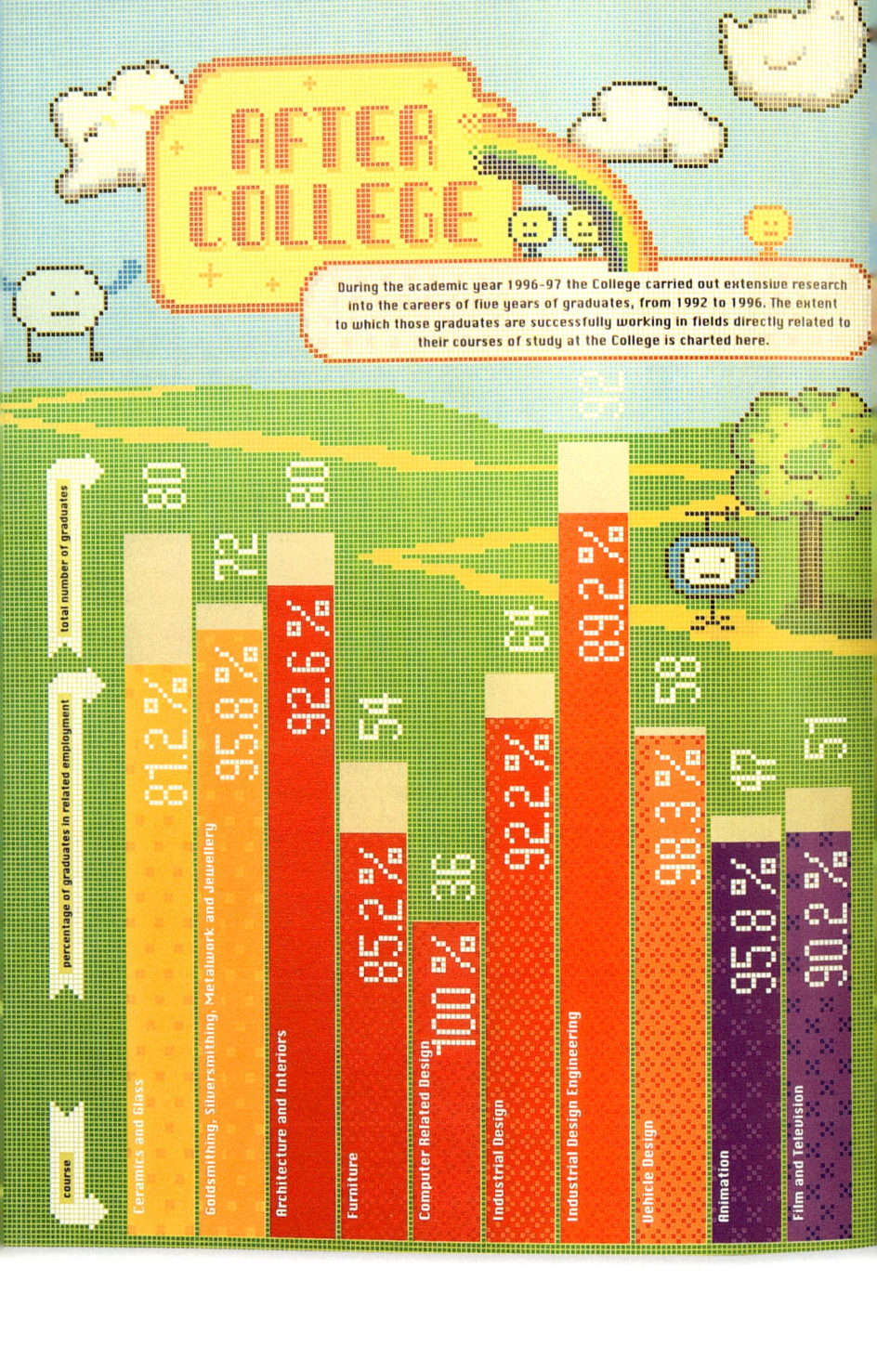

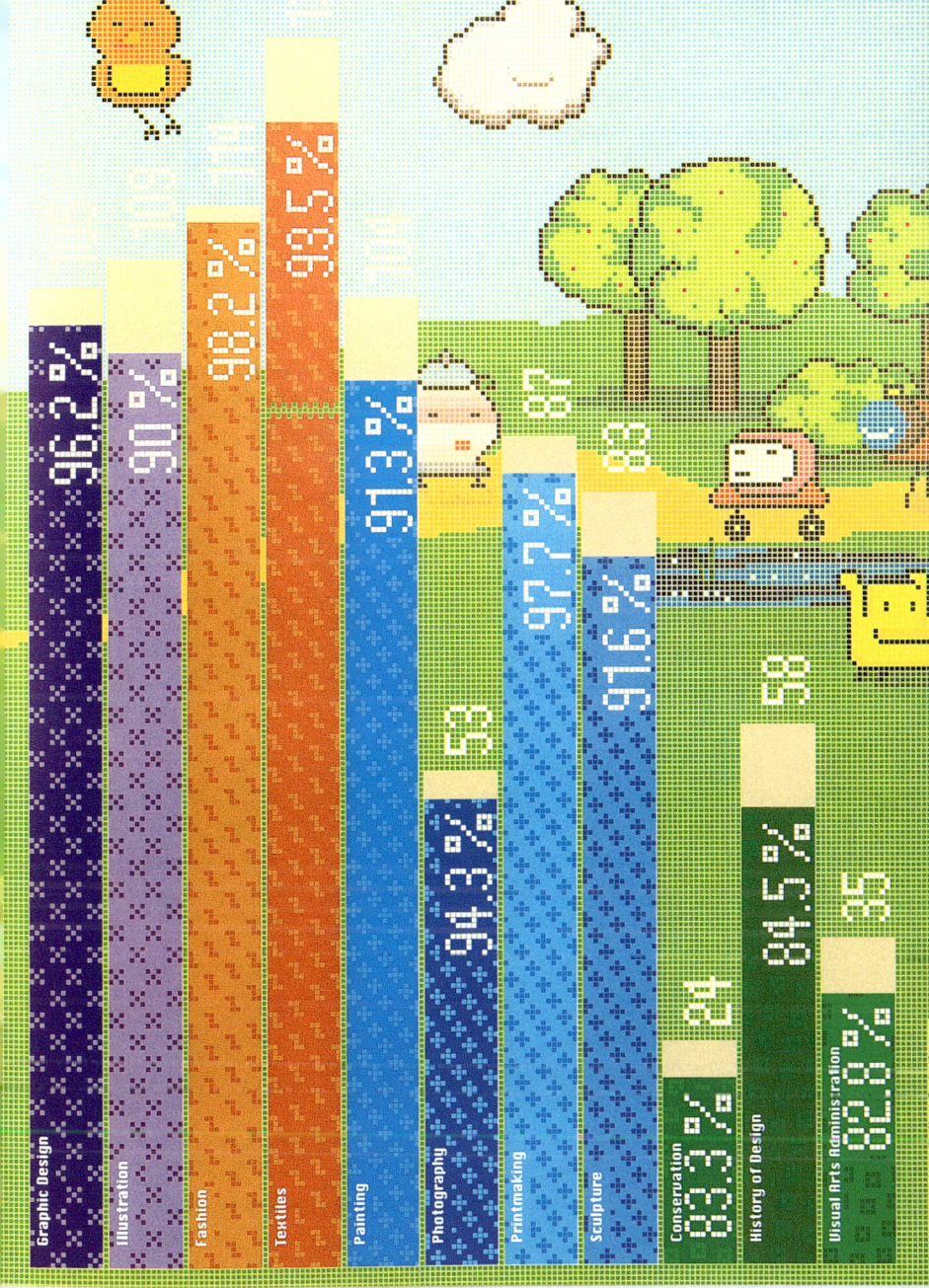

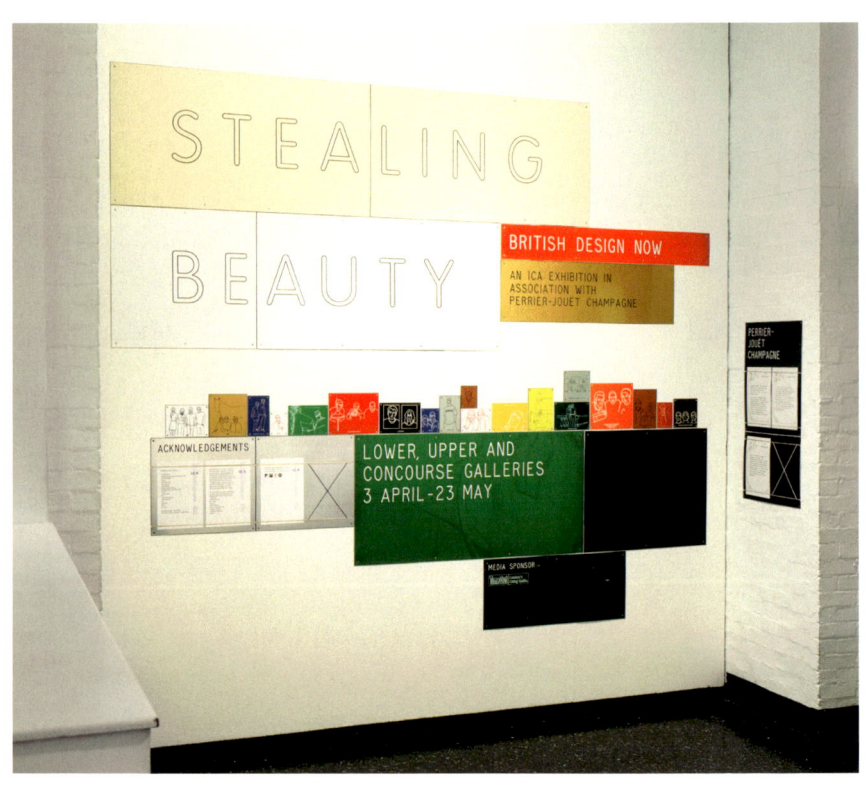

GTF, exhibition graphics for *Stealing Beauty: British Design Now*, Institute of Contemporary Arts, London, 1999.

and finishes of paper in an effort to develop unique graphic responses marked by a personal visual language that would engage viewers and hold their attention.

Stealing Beauty: British Design Now

In 1999 curator Claire Catterall recognized the importance of such designers as GTF, Tord Boontje, and Michael Marriott and their desire to bring about a "new kind of consciousness to the relationship between us and the objects we surround ourselves with."[14] She organized *Stealing Beauty: British Design Now* at the Institute of Contemporary Arts in London as a platform for investigating "ways of designing that are meaningful to both designer and user."[15] Catterall invited GTF to participate in the show because she recognized the part the firm played in this dialogue. Rather than contribute its own projects to be displayed as part of the exhibition, however, GTF proposed that it design the exhibition graphics and accompanying catalogue. Working with local workshops and foundries, GTF developed a signage program made from plastic laminate panels, engraved with illustrated portraits of each designer in the exhibition. Wall texts were also engraved into similar metal sheets. When presented together, the panels formed a collage of visual signage that one might more typically find in a warehouse, rather than in an art gallery. GTF also employed a vernacular language for the display of questionnaires penned by designers and members of the public. These were mounted on the walls on board and held in place with rubber bands. By plundering history for ideas and methods and by using low-grade materials, GTF effected an informal design language that mirrored the subject matter of the exhibition. Its strategy tied the projects together and provided an interpretive framework for understanding the objects on display.

The catalogue was equally low-maintenance. In an effort to present each work on commensurate terms, GTF revisited the concept they used for the RCA prospectus and asked each designer to provide photographs of his or her work. The varied images were printed in black and white, exactly as received. Setting them within a template that ordered them at the bottom right or left corner of the page helped regulate the diversity of materials. Also bound into the book were postcards, questionnaires, and even the sponsor's own logo, a label from a champagne bottle. The catalogue and ephemera were held together with a spiral binding such as one might get at a photocopy service center, further emphasizing the low-

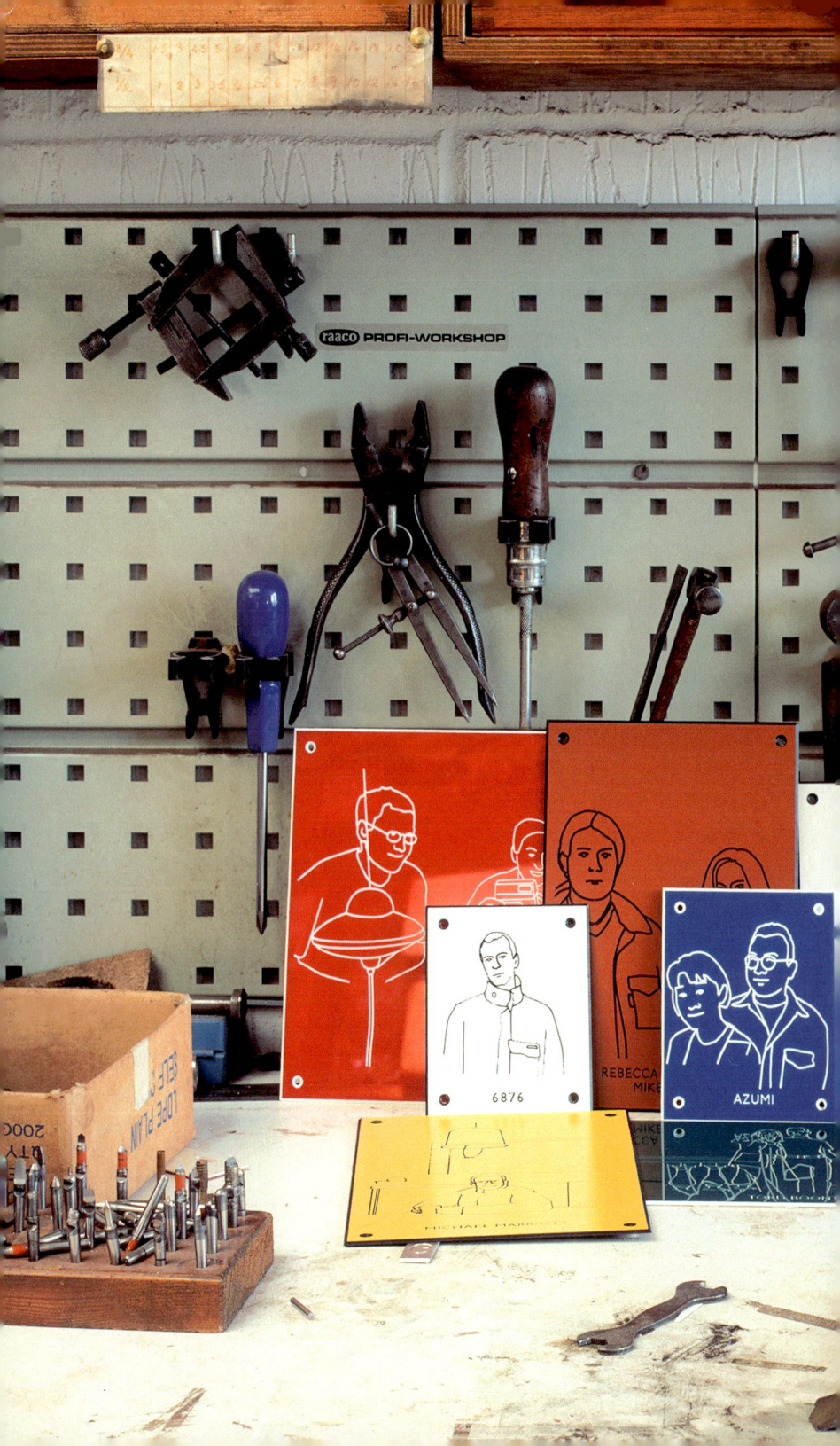

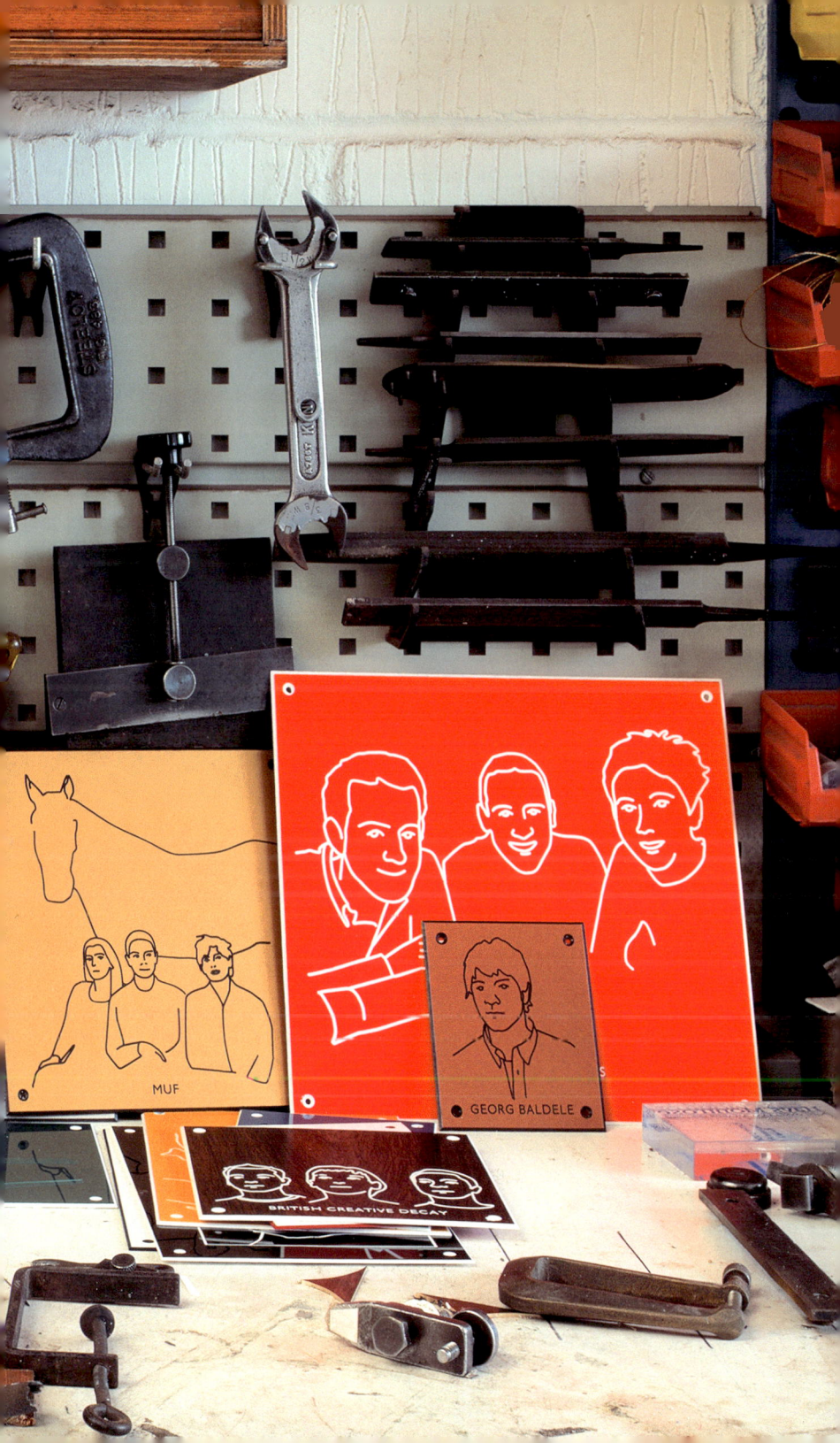

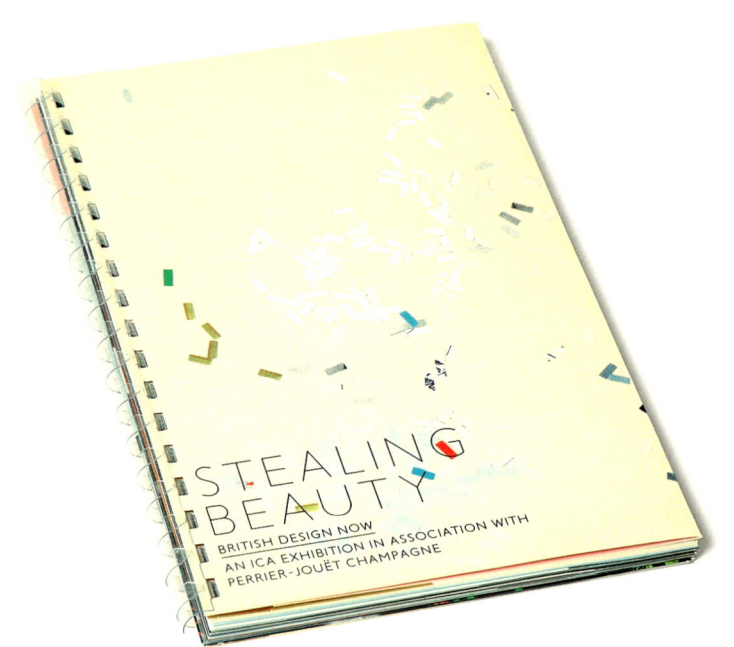

GTF, exhibition catalogue for *Stealing Beauty: British Design Now*, Institute of Contemporary Arts, London, 1999.

FAT

Below:–
'Novelist's House', London, 1998. A manifesto to 'genteel' living, utilising Georgian decorative motifs and avant-guard manipulations. The design suggests a revival of the 'Big P' — Postmodernism—offering an alternative to current architectural orthodoxies by referring to a largely reviled and discredited architectural style.

Right:–
'The Chez Garson', house conversion, London, 1996. A homage to Archigram's 'suburban sets' which examines the aesthetic of modern interiors where image is synonymous with lifestyle.

Insert:–
'Submarine House'
From the project Utopia Revisited (1997) Holly Street Estate, Hackney. As the estate was being demolished, alternatives were suggested based on residents' own Utopian ideals.

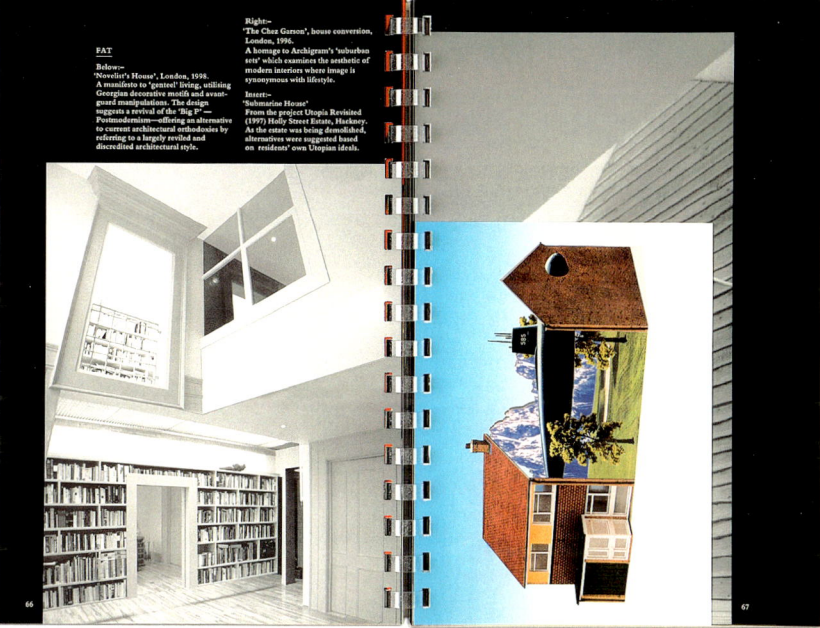

Name: Ann-Sofie Back

Please keep your answers to a maximum of 15 words.

Who do you design for? (Ideally)
I'm avoiding the subject. I've tried thinking about it, but just get confused. I don't understand what people want.

What effect do you like your work to have?
Relaxing?

Who/what has inspired you?
Anything that I didn't like. I like to improve things that I don't like.

Who/what inspires you now?
Unfit mothers on the dole, rubberbands, Swedish suburbia, Anna Cockburn and ~~the~~ the fine artist Markus Degerman (body and soul).

What is your favourite material and/or process at the moment?
T-shirts that are miscolored in the wash, black garbage bags and safety pins, + gypsy-lace dresses

Who/what would be your ideal client/commission be?
~~Cockburn and some money.~~ Anything involving Anna Cockburn and some money.

What do you avoid in design?
Clever tailoring

What is your first design memory?
I used to make something I called "parties" in my own room, where I gathered all things that I liked, they looked like huge installations. For me they were in perfect order and harmony. I've looked at photographs of them now and it looks like piles of crap, basically.

What is your worst design memory?
I designed a Versace-inspired umbrella once, aimed at the German market. This was Nº2 when I worked for Hennes & Mauritz.

What is the most cruel anybody could use (or has used) to describe your work?
I don't mind

Where have you found beauty in the ordinary and everyday?
At Citizens Advice

What was the last thing you stole?
I thought about stealing this beautiful rubberband I saw today. 2 cm thick and probably 40 cm diameter. It was lovely.

Describe/draw a favourite object.
I don't have favourite objects, nothing is that precious. People are ~~[scribble]~~ I can't

Page 23

key approach. Each book therefore appeared to be a unique edition made by hand, a concept that was stitched into the premise of the exhibition.

VISUAL SYSTEMS

GTF takes a systematic approach to design. The firm often works with brands and institutions over a number of years, developing a portfolio of projects that build on each other in strategic and creative ways to help strengthen their design. GTF regularly incorporates distinctive elements as the defining feature of a project, whether it be strong photography, the integration of illustration, a particular typeface, an unusual print process, or in the case of the *Stealing Beauty* catalogue, for example, an unexpected compilation of materials and binding. This core idea is translated at a number of different scales and within a variety of formats, and yet its constituent parts remain the same. Rather than being a restrictive process, this way of working allows for new relationships and design languages to occur, keeping the work fresh but at the same time reinforcing the visual message. For clients as varied as Habitat, the Design Museum, Frieze Art Fair, and Shakespeare's Globe Theatre, GTF has developed flexible identity systems, signage, packaging, books, retail products, and marketing materials that change with the seasons. Although each assignment is individual, each one is also meant to contribute to a larger program, a progression of an idea that builds on itself over time. GTF's interest lies in producing strong visual narratives that speak to the spirit and intention of a company or institution.

Habitat
Although many of GTF's clients are cultural organizations, the studio is also engaged in bringing its knowledge and interests to bear on commercial projects, as in the branding, identity, and marketing materials it created for the British retailer Habitat. GTF began working with the successful chain of home stores in 1995 under the leadership of Tom Dixon, who was then Habitat's design director. GTF's relationship with the company proved a fruitful partnership. Having produced a range of promotional materials and retail catalogues for Habitat, GTF was asked in 2000 to update its logo, without losing its brand recognition. Rather than start over, GTF modified the original Fry's Baskerville typeface by redrawing the serifs and increasing the height of the letters, just to freshen the familiar image. They also added what is now Habitat's trademark,

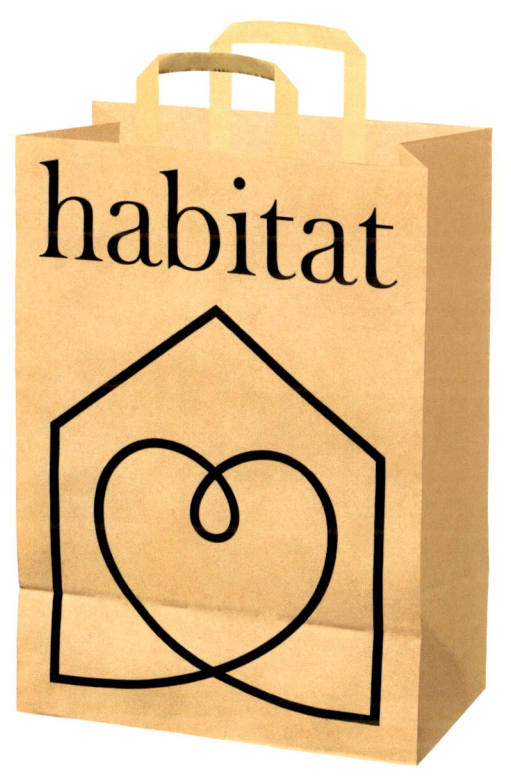

GTF, identity and marketing materials for Habitat, 2000–02.

BasicDeluxe

What is luxury?
Habitat's Autumn Winter 2001 range is more about an attitude than a collection of objects. It's a way of looking at the world, demanding luxury in the everyday and saying that mundane tasks need no longer be shabby or ⟨...⟩ domestic tools ⟨...⟩at you have ⟨...⟩o the everyday ⟨...⟩ pleasurable and ⟨...⟩

⟨...⟩uch in keeping ⟨...⟩les. In other ⟨...⟩ion should be ⟨...⟩sides, why ⟨...⟩reserve of an ⟨...⟩aces? By making ⟨...⟩ materials, we ⟨...⟩le bit of luxe

habitat
Autumn/Winter 2001

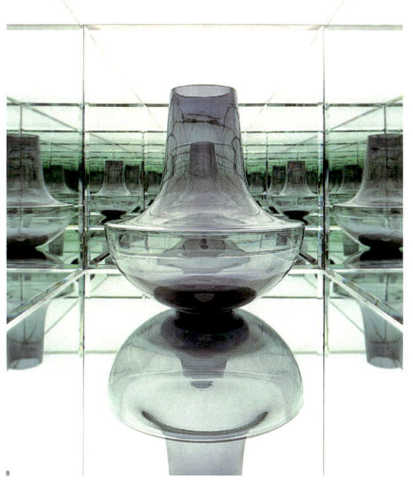
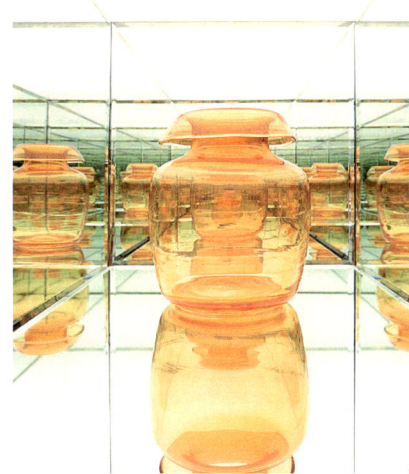

BasicDeluxe

...is quantity!
 Sometimes an everyday product becomes luxurious when it's displayed in bulk. In other words, things you can afford to buy lots of can become art when arranged en masse – a cluster of candles in cast iron holders (Triad) or arranged on stainless steel plates in magnetic holders (Symbian). Think big! A hundred simple wall-mounted candleholders (Beacon) could make a stunning wall of light. Your imagination is the only limit.
 BasicDeluxe is... scale.
 And sometimes an everyday product is luxurious because it's oversized. Imagine a vase, then imagine it bigger and shaped like a tear (Tear) or a wine glass (Goblet) or an old fashioned perfume bottle (Perfume). Mouth blown in Thailand, the vases were drawn life size, a strong man was found and they were made to order on the spot. It seems size matters after all!

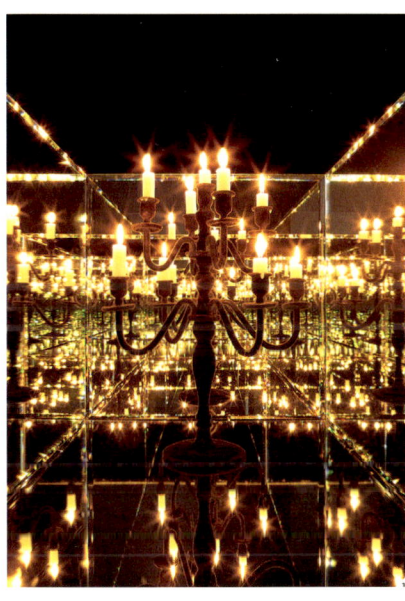

Computer rendering by Francois LeFranc.

a line drawing of a house with a heart at the center. This symbol has since come to distinguish the retail brand, and it adorns shopping bags, marketing materials, the Web site, and Habitat's own designed objects.

In addition to the logo, the work that stands out most among GTF's projects produced for the company over an almost ten-year period is its suite of seasonal marketing brochures, designed between 2000 and 2002. These slim publications, similar to those used in the fashion industry, previewed Habitat's collections. But as samples of objects were not always made in time to be photographed for the brochures, the main challenge of the project was to find a way to express, without them, the theme behind a campaign. GTF's strategy was to create a series of concept books—much like the mood boards found in designers' studios—that would provide a glimpse behind the scenes and communicate the inspiration driving a collection. For the first issue, published in spring/summer 2000, GTF relied on eye-catching imagery and took its lead from the theme "nature and technology." Lush green images of slender foliage photographed on metal and glass scanner beds provide an interesting contrast between materials and objects that speaks to the narrative theme. Other pages feature images of gardening tools, labels from vegetable shipping crates, and lengths of bamboo, again arranged on top of scanner beds. The photographs are printed on newsprint at large scale, and while a white border around them references the frames around works of art, it also provides the one formal element in this otherwise informal document, drawing the eye further into the image.

For the BasicDeluxe catalogue, published in autumn/winter 2001, GTF again explored the use of juxtapositions: the technological versus the handmade, text versus image, color versus black and white, decoration versus pared-down visual languages. In this instance, however, they were able to photograph many of the actual products. Thus, rather than take traditional shots of merchandise in domestic settings, GTF photographed objects in a mirrored box. The images are reminiscent of the sculptures and installations by artist Josiah McElheny. These pieces included a chandelier made from plastic cable ties, a black-velvet-flocked candelabra, and a dustpan and brush of shiny stainless steel. The myriad reflections of rows and rows of highly detailed objects appear to extend into infinity. In comparison to the visually stunning inner page spreads, the cover is treated in a much quieter fashion but with equal interest. A glossy quarter-page flap is folded around the cover and forms a contrast to the heavier, matte-finish paper of the catalogue. Printed in maroon

habitat

"ORNAMENTATION" CHRISTMAS 2001
"ORNEMENTATION" NOËL 2001
"ORNAMENTIK" WEIHNACHTEN 2001
"ORNAMENTACIÓN" NAVIDAD 2001

ESCLAVES DE LA MODE : FAITES REVIVRE LES DÉCORATIONS DE NOËL

Invoquez la magie des Noëls d'Europe de l'Est en transformant votre intérieur en un décor de fine slave. Commencez par décorer vos murs de rouleaux de palette naturelle SENDAY, de galons dorés ANASTASIA ou BALO, de paillettes brillantes VOLGA, et guirlandes chatoyantes dorées KALAKAN ou roses RAPENTHA, ornées de perles. Choisissez des vases aux formes somptueuses ERA, ROTLE et garnissez-les de fleurs aux parfums envoûtants. Ajoutez-y un éclairage réminiscent des églises, avec des bougies mixtes GOLDIE, IRIDESCENT et des bougeoirs baroques COLM, PLOTIT ou en verre de couleur décoré LUMEN, GEDO39, TORTO, TUVE. Placez quelques icônes dans des cadres dorés lourdement ornées BiCOCO, BAI ou en résine chatoyante FIGRE.

Le point central de votre Noël Slave sera bien sûr votre sapin : décorations traditionnelles CORK, clochettes TINEER, œufs décorés style Fabergé JANSTA, boules héritées MONEYPENNY, MCCURNASSE sans oublier une touche de Kitsch "Kremlinois" avec les discrets de neige velours et crochets PEGGY et CERTAIN, désormais utilisables en extérieur.

ECLAIRAGE SOMPTUEUX : DES GUIRLANDES ÉLECTRIQUES TRÈS FÉMININES

Rehaussez votre heureux décor de Noël avec un éclairage non moins somptueux. Disponible en 'traditionnel et 'piécée', si unique de table Pebble reflète le romantisme et la richesse de la palette de couleurs saisonnières d'Habitat, tout en vert Chartreuse, bleu Nil et rose framboise. Les formes florales de Petal et l'aspect traditionnel des lanternes Stack apportent une touche de féminité et de délicatesse à l'éclairage de Noël, s'associant parfaitement à des classiques de la collection Habitat comme MILLENIUM, PEARL et CERTAIN, désormais utilisables en extérieur.

RÉJOUISSANCES OPTIMALES : L'EXTRAVAGANCE AU MENU DU RÉVEILLON

En cette époque de festivités, il est bien naturel d'avoir des envies d'opulence en matière de décoration. Cela ne signifie pas pour autant une faute de goût. Le "maximalisme" est de mise sur la table du réveillon. Pour le célébrer, Habitat a sorti de l'oubli quelques grands classiques : retrouvez le napperon préféré de grand-mère BISTRO, son festin de décoration généreux numériquement pour votre service de table (un vrai parures de lit), brassées-vous pareille en équipant vos invités d'assiettes de fête style Sèvres et de couverts plaqués or très kitsch SWALLOW ; redécouvrez l'élégance du noir avec les assiettes et les plats en terre cuite TONGA ou bien ajoutez une touche d'Art Déco avec des mugs aux motifs audacieux BISTRO?

Pour un festin flamboyant à l'extrême, faites place à l'or : nappe en papier aux décor TAVOLA, seau à champagne bicolore brillant et coupes plaqués or GLITZY2, plateaux et saladiers en laiton SAFFRON5 ou résine décorée de fleurs or BARI12, et, comme coupes à fruits, prenez les paniers dorés KASHMIR.

LE CHOC DES COULEURS : DES TEXTILES QUI S'EXPRIMENT PAR EUX-MÊMES

Osez-vous dynamiser l'ennui du bon goût en matière de textiles? Associez les motifs à votre gré, avec une palette qui s'inspire de l'époque Art Déco. Choisissez une nappe en taffetas bicolore TOXIC ou rehaussée d'une bande de paillettes scintillantes DECO12 ou BIQUEYS10. Pour vous sur un pied DARJEELING17 en damassé rose, bleu ou or. Faites entrer la mode de la rue dans votre chambre, avec une couverpointe style Doudoune PUFFER, en ajoutez une touche de technoglitz avec housse de couette à pois PIXEL6 ou motifs fractals LACE3. Quant aux tenues de nuit, optez pour l'élégance orientale des chaussures PAPILLON et des kimonos ORI19 ou celle plus londonienne des pyjamas style Savile Row DOXSHIE.

Faites preuve d'originalité jusque dans le choix de votre papier cadeau. La gamme de papiers et de cartes de vœux Habitat vous offre rayures STRIPE5, brocart LUXURY6, formes géométriques DECO12, FLAKE10, fleurs DAMARK16, FLORAL20, effets multicolores ANEYMA19 ou imitations bois WOODIG19, ainsi que des carnets d'adresses et des albums photos décoratifs LEY10, des savons rapés SUDDS et des bougies ALPHA, à associer ou dissocier à votre gré.

L'HEURE DU JEU : JOUETS TRADITIONNELS AVEC UN PETIT PLUS

Le charme des jouets traditionnels ne s'est pas perdu. La collection Jouets et cadeaux d'Habitat comporte de grands classiques comme le "hobbie horse" HOBBIE (tête de cheval sur un manche), le bus londonien, l'adorable Chubb, petit bull-terrier à câliner, et Bubushka, version moderniste de la poupée gigogne. Mais si ces cadeaux reflètent l'innocence des temps anciens, d'autres sont beaucoup plus tendance et fermement ancrés dans le XXIe siècle : peluches en forme de téléphone portable TURNERIN, sac à main REGAA, jo60-d9à-REGA-91 ou lunettes de soleil KENSIT pour les 3-4 ans. Pour ces mini, la nappe qui se transforme en maison de poupées, avec 'fenêtre' de plié pièce rire pichets, et, comme cadeau à monsieur à ralliade, une Pâhitite comblé à qui rien ne manque, annoncez-le en lui offrant un yo-yo plaqué or ZETA ou occupez-le avec un nécessaire d'enfilage doré.

Illustration by Francois LeFranc.

with a white border, it acts as a title page with the name of the company and the date of the collection. Tom Dixon's introductory text, printed in black type across the white cover of the brochure, peaks out around the sides of the glossy flap tempting readers to learn more about Dixon's concept of "luxury in the everyday."

For the Christmas 2001 brochure, GTF went a step further in its use of ornamentation and illustration as a narrative and functional device. In recent years decoration has become an ascendant visual language in design, and in her 2005 essay "The Decriminalisation of Ornament," Alice Twemlow observed, "Over the past few years the pages we turn, the screens we summon, and the environments we visit have sprouted decorative detail, geometric patterns, mandalas, fleurons, and the exploratory tendrils of lush flora."[16] Rather than being surplus to requirements and harmful to human development, which is how Adolf Loos described ornamentation in his 1908 text *Ornament and Crime*, decoration in Twemlow's view has an important role to play in design, "as framing devices or carriers for critical or narrative commentary."[17]

GTF has never shied away from using ornamentation in its work. For the Christmas 2001 issue, inspired by the theme of decoration found in Eastern and Northern European folk art, the firm developed a highly illustrated catalogue with a bold color palette. The main visual focus is a series of digitally rendered Russian dolls of various sizes, adorned in multicolored prints, and arranged in gravity-free compositions that playfully float across the page. The free-form arrangements and text descriptions whet the appetite for this festive collection.

GTF again used contrasting gloss and matte papers within the spring/summer 2002 brochure. The majority of the brochure is printed on a heavier uncoated stock, except for the title page and project descriptions, which are done on a glossy white sheet that is cut in irregular shapes, slightly smaller in size than the rest of the book. Readers come across these pages, which act as content dividers, as they leaf through the brochure. For this collection, which was inspired by the Villa Noailles in Hyères, France, GTF made a scale model of architect Robert Mallet-Stevens's 1923–26 building and then photographed it at various angles. The shots were transferred to a computer and digital renderings of products were added to the all-white interior settings using Photoshop. The images were made to look digitally manipulated to draw attention to the products and furniture. Yet, by creating a real model of the building rather than using a drawing rendered on a computer, GTF ensured that the images

would have a far more powerful, three-dimensional quality and could in certain instances be mistaken for the actual villa.

Design Museum
In 2003 the Design Museum in London, under then director Alice Rawsthorn, invited GTF to work on rebranding this major institution, founded in 1989. GTF's process does more than just create logos: it serves to develop legible visual devices that can operate across a range of scales and materials from the logo, invitations, and posters through to environmental signage, all to better reflect the multiple narratives at play within the museum. The new identity for the Design Museum was intended to be the definitive element in a wider initiative to update the institution. GTF's starting point was to establish a system of signs and symbols that on the one hand would portray the multifaceted nature of design as represented within the museum, but on the other would be ambiguous enough to allow for individual readings and interpretation.

GTF decided early on that illustration would be a key component of the design and a fresh approach for the creation of a corporate identity. Kam Tang was engaged to develop a logo comprising a range of icons based on a list of activities, disciplines, "isms," objects, and programs at the Design Museum. His assemblage of forms is a compelling visual reference. Looking closely, one can discern many objects within a tightly packed composition—a computer mouse, interlocking chains, the print from a rubber tire, metal coils, a needle and thread, and an architectural fragment—and yet the image is abstract enough to encourage individual readings. Design Museum is printed in black in Schulbuch typeface across the center. The bold letters anchor the fluid composition and tie the disparate elements together. Neale has asserted that this unique treatment allowed the firm to inject a playful quality into the work (the icons), while at the same time grounding it with a more serious aspect (the straight-edged typeface).[18] The logo then became the knuckle of the entire identity system: for example, in the graphic signage within the museum, the icons are pulled apart and new relationships occur between them and the settings in which they are placed.

A third iteration of the logo played out in the materials for the "Designer of the Year" award, established in 2003. Tang introduced a new composition of icons that can be read on their own but retain the essential formal elements that associate them with the Design Museum. Although the layering of text over image creates the impression of three-

DESIGNER OF THE YEAR

TOM DIXON
THE GUARDIAN
JAMIE HEWLETT
CAMERON SINCLAIR

GTF, with illustrations by Kam Tang, identity for the Design Museum, London, 2003, and their "Designer of the Year" award, 2006.

dimensionality in the logo devices, it was not until the fourth year of the award that GTF took its design to the logical next step and created a three-dimensional version. Working with Timothy Rose, an artist based in California, they made a mobile of the logo from digitally cut pieces of melamine laminate with a high-gloss finish. Infused with color, the hanging object has a Pop Art quality.

Frieze Art Fair
In 2003 GTF was approached by Matthew Slotover and Amanda Sharp, the publishing directors of *Frieze* magazine, to create the identity, advertising, and marketing materials for the annual Frieze Art Fair in London. As in the project for the Design Museum, GTF was required to think in series and multiples. What is most striking about its graphic solution is that it has less to do with the content of the art fair and more to do with where it is staged, Regent's Park. The site has in fact become the branding mechanism for the annual fair. The flora and fauna, picnics and soccer matches, and ducks and squirrels that characterize this urban park have been the focus of posters, invitation cards, advertisements, and catalogues. Regent's Park is the stable element that ties this transitory art fair together.

Aside from the visual elements that characterize the marketing and press campaigns, the other dominant feature of the firm's design is the logo for the fair. Borrowing Julian Morey's Jakarta typeface, GTF created a logotype made from stenciled lettering, an idea inspired by markings and labels on shipping containers and derived from the transient nature of the fair, which runs for four days each year. The resulting logo, found on all fair materials, is framed at all four corners by straight-edged brackets that give the impression of a stamp and also allude to the framing of artworks.

The visual direction for the range of materials developed for the fair over the past five years has been on pragmatic considerations. Rather than select one artist's work over another as the predominant graphic or use color as the defining feature as other art fairs have done, GTF was instead drawn to the one constant in the fair, its location. For the inaugural show in 2003, the firm developed a series of images of the park shot over twelve months with the same horizon line and at the same scale, providing comparable views over time. The photographs were printed at full bleed across invitation cards, posters, and advertisements. In 2004 GTF collaborated with photographer Angela Moore, who documented

Photography by Angela Moore.

GTF, identity, advertising, and marketing materials
for Frieze Art Fair, London, 2004–07.

Frieze Art Fair
Regent's Park, London
15–18 October 2005

For more information:-
Telephone +44 (0)20 7692 0000
Email info@friezeartfair.com
www.friezeartfair.com

FRIEZE ART FAIR

FRIEZE ART FAIR

Frieze Art Fair
Regent's Park, London
12–15 October 2006
www.friezeartfair.com

Book Now for discounts
and fast track entry
Box Office: See-Tickets
+44 (0)870 890 0514

Photography by High Spy.

Top: Photography by Angela Moore.
Above: Photography by High Spy.

Above: Photography by Angela Moore.

Frieze Art Fair
Regent's Park, London
11–14 October 2007
www.frieze.com

Tickets available from
+44 (0)870 890 0514
www.seetickets.com

FRIEZE ART FAIR

Photography by Angela Moore.

the construction of the temporary structures that house the fair. The still images of empty structures in the process of being built anticipate the throngs of fairgoers, the densely hung artworks, and the mass of paraphernalia generated for such an event. In 2005 GTF recorded the wildlife in the park. The carefully cropped images of native animals—a duck, a squirrel, a hedgehog, and a pair of caterpillars—depict the everyday inhabitants of the park, often overlooked during the event, and are an unexpected counterpoint to the urban program. In 2006, rather than use images taken from the ground, GTF worked with High Spy, an aerial photography company to capture the park from above. The long-range images provide bird's-eye views of the park and highlight elements not otherwise legible, such as the tonal colors of the inside of the boats on the pond and the patchwork of different foliage in the park, accented with the bright colors of picnic blankets and people's clothing. GTF returned to the park in 2007, but this time at night. Teaming up again with Moore and a theatrical lighting company, the designers art directed a series of photographs of trees illuminated in moody tones of blue, orange, and purple to dramatic effect. These images in particular depict the park as a stage on which the art fair is played out.

Shakespeare's Globe Theatre
Photography has continued to play a fundamental role in GTF's work, including projects for Shakespeare's Globe Theatre in London. In 2000 GTF was commissioned to rethink the design of the Globe's printed materials for performances at the theater. Working with practitioners from across disciplines enables GTF to locate its projects within new and potentially stimulating contexts that can inspire interesting results. In this case, the firm was able to subvert standard theater photography in an effort to portray the unique character of the Globe, which is a reconstruction of the Elizabethan arena, built close to the site of the original.

For the 2003 and 2004 season of plays, GTF commissioned photographer Nigel Shafran. Rather than capture performances onstage, GTF asked Shafran for images of actors engaged in activities offstage. One photo shows an actor being helped into his costume, another is pictured resting in the greenroom (a members-only space for players), and a third actor dressed in sixteenth-century costume stops to get a snack from an automated machine. The images are unexpected and catch a rare glimpse behind the scenes. Most importantly, the acute juxtapositions between the modern context (exit signs, coffee machines,

Photography by Nigel Shafran.

GTF, programs, brochures, and posters for performances at Shakespeare's Globe Theatre, London, 2003–06.

1/2

Shakespeare's Globe Theatre 2003 *The Season of Regime Change*

MICHAEL BROWN, TIRING HOUSE, 2002

'I am Richard II, know ye not that?' said Queen Elizabeth I, enraged by Shakespeare's revolutionary play after it was performed in the Globe on the eve of the so-called Essex Rebellion. Elizabeth died on March 24th 1603, and later that year James I of Scotland succeeded her to the throne.

400 years after that transition from Tudor to Stuart rule, and faced with a modern world which increasingly turns to violence in order to effect security or regime change, I offer you a season at the Globe which explores power and change on three levels: in our states, in our marriages, and in our relationship to the divine.

Shakespeare's tragedies, *Richard II* and *Richard III*, and Marlowe's tragedy *Edward II*, all reveal the struggle between the personal affections and the worldly responsibilities of the powerful. The familiar change from individual to married couple has never been so controversially explored as in Shakespeare's comedy *The Taming of the Shrew*. And the rarely played *Dido, Queen of Carthage*, drawn from Virgil by Christopher Marlowe, proposes that all our changes in matters of love and state may in fact be responses to divine influence.

For the first time we introduce a Women's Company to partner our familiar Men's Company. Shakespeare's original actors were not limited by the gender of the parts they played, but enjoyed a revolutionary theatre of the imagination where commoner played king, man played woman, and, within the plays, woman man.

It is the presence of your intelligent, humorous, and generous imagination in the Globe which inspires our creation. I look forward to seeing you once again.

Mark Rylance Artistic Director

PETER SHOREY, TIRING HOUSE, 2002

11/12
Opens 10 August
The Taming of the Shrew
By William Shakespeare

The Women's Company An all female production exploring clothing, music, dance and settings possible in the original Globe of 1603

Master of Play Barry Kyle

The Taming of the Shrew is one of Shakespeare's most famous, funny and controversial plays. It tells the story of Petruccio, a young man from Verona in search of great wealth in Padua. He meets Katherine, a strong-willed soul, notorious for her wit and independence. Tempted by the promise of a favourable dowry, and eager to help his friend woo Katherine's younger sister Bianca, Petruccio sets about courting the reluctant 'shrew'.

With its infamous final scene, when the bond between Petruccio and Katherine is finally put to the test, *The Taming of the Shrew* is a tale of the change of regime between an independent man and woman when they unite in love and marriage.

COLIN HURLEY, GREEN ROOM, 2002

ALBIE WOODINGTON, SMOKERS' BALCONY, 2002

Photography by Nigel Shafran.

The Season of the
World & Underworld
6 May – 2 October 2005

SHAKESPEARE'S GLOBE THEATRE

THE TEMPEST
THE WINTER'S TALE
THE STORM
PERICLES

700 × £5 TICKETS AT EVERY SHOW

Bankside, London SE1
Ticket sales 020 7401 9919 / 020 7850 8590
www.shakespeares-globe.org

notice boards, and backstage furniture) and the historical performances onstage (architecture and costumes) arouse contemporary readings of the Globe Theatre.

In 2005 GTF produced the photographic content of the programs. Motivated by the performances that year—*The Tempest*, *The Winter's Tale*, *The Storm*, and *Pericles*, all of which deal with personal relationships—the designers focused their lens on the unique angle of the audience. GTF took the pictures from within the crowd who stand at shoulder height to the stage, looking up at the actors. The photographs capture the expressions of the theatergoers, which prompt the viewer to imagine what is happening onstage. In other photographs, the drinks and snacks placed at the edge of the stage come forth, juxtaposed against the feet and ankles of the performers. Other images spotlight the colored raincoats of the members of the public, underscoring the inimitable character of this open-air venue. It is the unmediated and unexpected experiences that stand out in these photographs and make them so appealing to viewers accustomed to seeing staged theater photography.

For their most recent body of work for the Globe, produced for the 2006 season, GTF abandoned photography and instead utilized illustration as the predominant visual language. This direction was prompted by the title of the new season, "The Edges of Rome," a series of political plays centered on the capital city. Influenced by the history of graffiti that is unique to Rome and that began with images carved in stone and evolved into political slogans spray painted on the city's architecture in defiance of the government, GTF art directed a series of images specific to the six plays in that season, which were spray painted by Nick Higgins. These included a silhouette of a wolf and two children signifying the mythical she-wolf in Shakespeare's *Coriolanus*, a black dripping heart to represent *Antony and Cleopatra*, and a pirate's skull and crossbones, which set the tone for Simon Bent's *Under the Black Flag*. The cover of each program was created by overprinting the new image on the previous one. The final program is an amalgamation of all six drawings, with the design for the final play appearing on top. Like printer's proofs, the backs of the programs retain the spray-painted marks from each design, subtly exposing the technique. The result is an explosion of image and color that reflects the potent content of the plays.

A MODERN practices production exploring clothing, music, dance and settings possible in the Globe of 2005.

Having discovered a dangerous secret at the court of Antiochus, Pericles is forced to flee his own kingdom and wander the world. He arrives, shipwrecked, in Pentapolis, where he is saved by fishermen and wins Princess Thaisa for his wife.

Shortly afterwards, however, Thaisa dies at sea giving birth to a child: Marina. Pericles fosters this daughter to a friend. When Marina is also reported dead some years later, he falls into a speechless grief. The story culminates in the redemption of the long-suffering Pericles through a series of seeming miracles.

Kathryn Hunter and Liz Cooke worked together on the 1999 Globe Theatre Company production of *The Comedy of Errors*. Their powerful, physical style of theatre will make for a fascinating interpretation of this mythical play.

MASTER OF PLAY Kathryn Hunter
DESIGN Liz Cooke
MUSIC Stephen Warbeck

OPEN REHEARSALS 18 & 19 MAY (see page 18)

PERICLES, PRINCE OF TYRE

A COMEDY BY WILLIAM SHAKESPEARE
OPENS 20 MAY

*O, come hither,
Thou that beget'st him that did thee beget,
Thou that wast born at sea, buried at Tharsus,
And found at sea again! ... This is Marina.*

An original practices production exploring clothing, music, dance and settings possible in the Globe of 1599, with a modern company of men and women players.

Leontes, King of Sicilia, is convinced that his wife Hermione has committed adultery. So blind is his rage that even a proclamation from the Oracle of Apollo fails to convince Leontes of Hermione's innocence. His implacable jealousy has terrible consequences, leading to the rupture of his lifelong friendship with the King of Bohemia, and the death of his wife and son.

Only Leontes' infant daughter Perdita, sent to her death but saved by shepherds in Bohemia, survives to redeem the story.

Presented by the creative team behind the Globe Theatre Company production of *Measure for Measure*.

MASTER OF PLAY John Dove
DESIGN Jenny Tiramani
MUSIC William Lyons and Claire van Kampen
OPEN REHEARSALS 2 & 3 JUNE (see page 18)

THE WINTER'S TALE

A COMEDY BY WILLIAM SHAKESPEARE
OPENS 4 JUNE

*Faire madam kneel, and pray your mother's blessing:
turn good lady, our Perdita is found.
Hermione: You Gods look down,
And from your sacred viols pour your graces
Upon my daughter's head.*

SHAKESPEARE'S
GLOBE
THEATRE
THE EDGES OF ROME
CORIOLANUS
BY WILLIAM
SHAKESPEARE

SHAKESPEARE'S
GLOBE
THEATRE
THE EDGES OF ROME
TITUS ANDRONICUS
BY WILLIAM
SHAKESPEARE

**SHAKESPEARE'S
GLOBE
THEATRE
THE EDGES OF ROME
UNDER THE BLACK FLAG
BY SIMON BENT**

**SHAKESPEARE'S
GLOBE
THEATRE
THE EDGES OF ROME
THE COMEDY OF ERRORS
BY WILLIAM
SHAKESPEARE**

Illustrations by Nick Higgins/GTF.

SHAKESPEARE'S
GLOBE
THEATRE
THE EDGES OF ROME
IN EXTREMIS
BY HOWARD BRENTON

GTF is adept at working across scales and going from two dimensions to three dimensions and back again. Or it can develop aspects of a project in three dimensions and then translate them into a two-dimensional format. A good example is the architectural model of the Villa Noailles made for the spring/summer 2002 Habitat catalogue or the illuminated scenography for Frieze Art Fair in 2007. GTF undertook such transitions to create work that was less about digital technologies and more about the craft of graphic design. For GTF the computer is a necessary tool but one that need not make obsolete analog processes that might afford a higher level of creative expression. The limitations of the computer have been astutely addressed by designers, computer scientists, and media artists such as John Maeda, whose own thoughts mirror GTF's but allude to the technology itself rather than the output. Maeda finds it unfortunate "that the display technology of the computer we use has been designed around the flat, rectangular metaphor of machine cut paper, instead of the unflat, unrectangular, and infinitely multidimensional space of pure computation."[19]

GTF's integrated working methods manifest themselves most notably in the range of publications they have worked on, from exhibition catalogues and monographs to art books, fanzine-style commercial brochures, and monthly retail magazines. Through research into new materials, papers, inks, and production processes, GTF works to challenge assumptions about the spatial, tactile, and visual elements of a book and their designers endeavor to make their publications interesting objects in their own right.

Ron Arad
In 2003 GTF worked with Ron Arad on a monograph for Phaidon Press, published the following year. The book was a fitting collaboration given their related interests and Arad's early experiments as part of the Creative Salvage movement. The main thrust of the book is a conversation between Arad and art critic Matthew Collings. Photographs shot by Nigel Shafran of the two in conversation accompany the text, along with images of Arad's products, furniture, and architectural designs. Resembling a design handbook in its square format and ordered layout, the book illustrates GTF's systematic approach and innate design sensibility. Most notable about the design is the cover image that was

GTF, book design for *Ron Arad Talks to Matthew Collings* (Phaidon), 2004.

White and Stones
Baling machine for chairs
1985

We made this installation piece for 'Les Nouvelles Tendances', an exhibition held at the Centre Georges Pompidou in Paris in 1985. Parisians were invited to bring chairs to the museum, place them on a conveyor belt and watch them be turned into bricks. Over the six months the exhibition lasted, an ever-growing wall of compacted chairs was constructed. After the exhibition closed, the machine spent a number of years travelling to several locations world-wide.

the next-youngest person after me and we both sneered a little at the others. I mean Starck was beginning to be an event in Paris: the first design star. At least he was the first to come from France after a long time.

Cuttings
Yes, he did toothbrushes or something, didn't he?

Arnet
A bit later, but yes.

Cuttings
They were bendy?

Arnet
Very French, very stylized toothbrushes. He's a very witty stylist. But, yes, I felt good, but also I was a misfit there.

Cuttings
Why?

Arnet
Well, because of the programme. 'Habitation for the Future'. In my statements to the organizers I said I wasn't interested in the future. All I could do was make it come a little faster. And the only way I could do that was by destroying some of the – well, maybe sort of living up to the false pretext on which I was invited, this idea of the Ruinist. I said the most important machine in the car industry is really the machine that destroys cars, because it makes room for new ones. And when you move into a new place, you don't open the wardrobe and say, 'Let's see what I have to wear here'. Your clothes are your own. You bought them for yourself alone. But with design and furniture, and things like that, people don't expect changes to come so fast. There are still the same standards, the same heights all the time. So my project for that exhibition was that I built a huge machine in the Pompidou Centre that started with a conveyor belt. And I invited Parisians to come to the museum with their favourite piece of furniture – or their least favourite piece – and to place it on the conveyor belt. And then it was crunched and compressed. I said if they wanted the future to come they had to make a sacrifice.

Cuttings
You did Michael Landy fifteen years before him?

Arnet
Yes, I talked to him about it the other day. But mine was a little different. In fact it was more like César. And to show Parisians I knew a little history, I called it Cesarian Operation.

Cuttings
You wanted to refer to the squashed car guy: the artist, César, from the 1960s? It's remarkable that we don't really have an equivalent of the Pompidou here: there isn't that excitement about art and design and architecture, and arguments, and attitudes, and so on, all being theatricalized in that way or given a big public form...

5
Doors strangely closed Bricks, Neo-Geo, lights going on and off Being serious

Photography by Nigel Shafran.

especially commissioned for the book: it features a sculptural object made by Arad using rapid-prototyping technology. Although Arad is known for exploiting the possibilities of this process to create vases and lights, it was the experiments with his own handwriting to generate three-dimensional models of his signature that caught GTF's eye. They asked Arad to make a similar model of his signature conjoined with one of Matthew Collings's signature as a metaphor for their conversation. Photographed by GTF for the front cover, the extruded form looks like a piece of hardened sticky toffee inscribed with their names at either end; a fitting gesture for this playful designer.

Tord Boontje
In 2006 GTF's insightful approach was noticed by designer Tord Boontje, who was himself known for the perfect marriage of poetry and function. Boontje asked GTF to design his first monograph, published in 2007 by Rizzoli. GTF principals met Boontje while working on *Stealing Beauty* in 1999, but built a relationship with him in 2002 when they created the packaging for his Wednesday Light. This design gave them the opportunity to share their combined interest in experimenting with working processes, in this case photogram techniques. Photograms received wide attention in the early part of the twentieth century from such artists as Man Ray and László Moholy-Nagy, who pushed the expressive possibilities of the medium beyond that of documentation. GTF created the decorative packaging by wrapping the Wednesday Light around a box covered in photographic paper, exposing all six sides to a light source in a darkroom, and then developing the images. The photograms capture the sharp graphic lines of the lamp's intricate design and at the same time reveal the nuances of light and dark tones that give the impression of three-dimensionality.

Working on Boontje's first retrospective publication four years later, GTF's initial mandate was to conceive a format for the book that would do justice to Boontje's visually complex and detailed designs. GTF persuaded Boontje to rephotograph his major works so they could control the presentation, quality, and size of the images to achieve maximum effect. Angela Moore and Annabel Elston worked independently over a two-month period and shot more than 150 works at Boontje's studio in Bourg-Argental, in southeastern France. Boontje art directed each photograph and built the sets. Each image was taken in medium format at six by seven inches, which became the default size of the book. GTF

GTF, packaging for Tord Boontje's Wednesday Light, 2002.

GTF, book design for *Tord Boontje* (Rizzoli), 2007.

Top and above: Photography by Angela Moore.

Top: Photography by Annabel Elston.
Above: Photography by Angela Moore.

Being & Becoming

Books and the arts offer knowledge and ideas, tell stories and draw out emotions. Design shapes the world in tangible, non-verbal ways. Tord Boontje was born into the social and political watershed of 1968. Connecting this triangle of culture, creativity, and experience has given Boontje a singular presence in the design world in the early years of a new millennium.

How does such a designer come to be: what is the balance struck between nature and nurture? What is the culture in which the kernel of ideas can flourish and find expression? For Tord Boontje, life began in Holland in Enschede, notable only as the location for John Enschede's print works in the 1860s where he designed his remarkable typefaces and graphic borders. Home and childhood for Boontje were focused on his immediate family and the interests encouraged, above all, by his mother, Carina Edlund. "We didn't have much" is the telling comment the designer makes, seeing this as the positive framing of a childhood spent making things, exploring materials in and out of doors, enjoying stories, painting, drawing, cooking. Resourcefulness, which characterizes so much of the designer's later approach, was a method of living from the earliest stage.

Boontje's parents had straightforward lives and aspirations. His Swedish mother trained and worked as a textile designer and his Dutch father was a salesman for a transport company. "He was assigned to Sweden and that's where they met and got married and moved to Holland. That's where I grew up and then for a long time my mother didn't work; she had three children," including his older sister Cindie and younger brother Adri, the three of them each eighteen months apart.

Throughout his childhood he was actively creative, his mother recalls. "If it was a rainy day all the children around us were coming to us and we were making things, drawings, cutting out houses and roads for cars." She also helped at her children's school in the early years, teaching them and others textile techniques in the creativity hours, "one year knitting, one year embroidery." The freedom experienced in these childhood years has allowed Boontje to place a premium on experimentation and hands-on drawing and making in the development of ideas.

The aspect of making filtered from his maternal grandparents—his grandfather an engineer and inventor, his grandmother a weaver. Holidays with them at their house in Bromma near Stockholm were a source of pleasure and influence, full of looms, books, workshops and open space to roam freely. While they had guinea pigs or a cat at home, out in nature his mother remembers, "we were very open and tried to look at the birds or see if a mouse or bigger animal was there." Boontje confirms: "We loved going there at summer and Christmas; we were always very excited."

Photography by Angela Moore.

did not crop any of the images but tipped them into the layout as they were. Printed in color on glossy paper, the arresting images of Boontje's furniture and product designs photographed in the dense woodland around his studio form a visual diary of his masterful creations over the years. The images act as chapter breaks and establish moments of pause in the flow of narrative essays by Martina Margetts.

Margetts's descriptive texts are printed on heavier, uncoated paper with a quieter design. Each page is framed by a decorative margin like that found in illuminated manuscripts. Silhouettes of birds and flowers are made from tiny holes punched into the paper. These motifs, found in Boontje's designs, are here re-created on paper. The cover of the book has been treated with equal care. Verdant floral patterns peak through a mull-gauze wrap that folds around the volume. The fabric is typically used in bookbinding and gives the impression that it was made by hand rather than with the help of printing technology. The design of the publication is as beautiful and tactile as Boontje's captivating creations.

New Art Up-Close
Another book that functions as an object of enquiry is the New Art Up-Close series that GTF began working on with Royal Jelly Factory in 2003. Founded in 2003 by Lucy Head and David Barrett, this independent art publishing firm is known in the UK for its affordable, pocket-size publications dedicated to work by international, living artists. GTF designed the template for the books and has since worked on realizing the first three on artists Gary Hume, Gavin Turk, and Jake and Dinos Chapman. The resulting design solution makes ingenious use of the flap on the inside of the cover, which is folded through a die-cut slit on the front of the book. The narrow tab of the flap that pokes through the cover is printed with the name of the artist. When the flap is unfolded, the cover image is unobstructed. This signature design element functions as the branding mechanism for the book and is repeated on all New Art Up-Close publications.

I Am A Camera
In 2001 GTF was commissioned to design a catalogue for an exhibition of contemporary photography organized by the London-based gallery owner Charles Saatchi. Titled *I Am A Camera*, the exhibition was named after a 1951 play by John Van Druten, and inspired by Christopher Isherwood's *Berlin Stories*. The show was organized into three themes:

GTF, template and book design for the New Art
Up-Close series (Royal Jelly Factory), 2003–04.

GTF, book design for *I Am A Camera*
(Booth-Clibborn Editions), 2001.

82
Ashley Mitchell
Untitled
From the series *Love Letter*
2000
C-print
101.6 × 152.4cm / 40 × 60in

I AM A CAMERA
THE SAATCHI GALLERY
BOOTH-CLIBBORN EDITIONS

223
Rineke Dijkstra
Kolobrzeg, Poland, July 26, 1992
1992
Colour print
190 × 150cm / 74³⁄₄ × 60in

224 (vertical)
Rineke Dijkstra
Coney Island, NY, USA, June 20, 1993
1993
Colour print
190 × 150cm / 74³⁄₄ × 60in

225 (vertical)
Rineke Dijkstra
De Panne, Belgium, August 7, 1992
1992
Colour print
190 × 150cm / 74³⁄₄ × 60in

226 (vertical)
Rineke Dijkstra
Odessa, Ukraine, August 4, 1993
1993
Colour print
190 × 150cm / 74³⁄₄ × 60in

227 (vertical)
Rineke Dijkstra
Dubrovnik, Croatia, July 13, 1996
1996
Colour print
190 × 150cm / 74³⁄₄ × 60in

"True Life Adventures," "Fiction and Artifice," and "Places Portraits Still Lives Tableaux." This survey included work by Sam Taylor-Wood, Jessica Craig-Martin, Andreas Gursky, Nan Goldin, Andres Serrano, and Cindy Sherman. The development of the catalogue happened alongside the organization of the exhibition. GTF created a flexible internal layout for the publication that did not conform to typical book designs. Rather than putting the title page on the first inside page of the book, as is conventional, the title appears on page 121. The first section of images begins on the cover and runs through to the title page, followed by the second set of visuals, an essay by Martin Maloney, and then the third section of photographs. This unusual approach allowed for images to be added or subtracted as the exhibition was finalized, without altering the overall flow of the book. The unusual structure of the catalogue provokes us to rethink quotidian experiences that we often take for granted, such as how we read and understand the structure of a publication.

54th Carnegie International
In 2003 GTF began work on its first commission in the United States, a project for the 2004–05 Carnegie International, a survey of contemporary art in America, with a history dating back to 1896. Hired by curator Laura Hoptman to create the graphic identity of the exhibition and its accompanying catalogue, GTF developed a design that was a reference to the heritage and prestige of the Carnegie Museum of Art in Pittsburgh, which stages the biannual show. Just as GTF salvaged found materials for the *Stealing Beauty* catalogue or played with juxtapositions of typographies, color versus black and white, image versus text, and different materials in Tord Boontje's monograph, here it also challenged convention in the use of old typologies, updated and reinterpreted. GTF is fully aware of the implications of juxtaposing design processes and visual languages and conjoining old techniques with new. The firm's designs are a nod to a long history of experimentation, but they remain framed within a contemporary idiom.

For the Carnegie International, research led the GTF team to revisiting old world book components. On one level the design resembles that of traditional art-historical volumes, while on closer inspection traits of contemporary art-book design are engaged throughout with interesting effects. For example, GTF exploited the use of cloth binding and created for the fabric wrapping the book a decorative pattern made from the title

54th Carnegie International
Carnegie Museum of Art

Exhibiting Artists
Tomma Abts
Pawel Althamer
Francis Alÿs
Mamma Andersson
Chiho Aoshima
Kaoru Arima
Kutlug Ataman
John Bock
Lee Bontecou
Robert Breer
Fernando Bryce
Kathy Butterly
Maurizio Cattelan
Paul Chan
Anne Chu
Robert Crumb
Jeremy Deller
Philip-Lorca diCorcia
Peter Doig
Trisha Donnelly
Harun Farocki
Saul Fletcher
Isa Genzken
Mark Grotjahn
Rachel Harrison
Carsten Höller
Katarzyna Kozyra
Jim Lambie
Mangelos
Julie Mehretu
Senga Nengudi
Oliver Payne and Nick Relph
Araya Rasdjarmrearnsook
Neo Rauch
Ugo Rondinone
Eva Rothschild
Yang Fudong

CARNEGIE INTERNATIONAL 2004–5
CARNEGIE MUSEUM OF ART, PITTSBURGH
LAURA HOPTMAN, CURATOR

Pawel Althamer

Is Pawel Althamer the Joseph Beuys of the twenty-first century? The latter's highly influential ideas about art focused on involving society at large in artistic and creative production. Beuys' participation in politics and social service led him to become a founding member of the Green party in Germany. Althamer's approach to creative production and the role of the artist mirrors certain aspects of Beuys' actions, but his focus is on a much more narrowly defined group of people, the artist's inner circle of family and friends.

Althamer shares with Beuys a religious attitude toward his own role, as an artist, in the transformation of society. The way he looks at reality is intimate, personal, and psychological. For him, the way to change the world is by addressing our immediate surroundings. Althamer's actions—very private in nature and unlike the heroic gestures that many artists are used to producing—are reflective of his own inquiry into what it means to be here in this world: he invited an old friend, who left their native Warsaw a long time ago, to move temporarily to Chicago to perform his daily job as a house painter at the Museum of Contemporary Art for the duration of Althamer's show there in 2001; he has driven across Europe with his immediate family and close relatives, transforming leisure, tourism, and travel into a work of art; he has fired simple ashtrays in the manner of ancient Japanese pottery to produce a mind-raising multiple for the Kunstverein in Cologne. If Beuys was professing awareness of the regal individual, Althamer is searching for the true humbleness to be found in human nature.

Sleeping in a tree in the middle of winter or driving the old car; at this exhibition through a pair of glasses without lenses only to discover that the "show" is nothing more than a small run-down alley behind the gallery space are, for this artist, moments that create awareness of context and of its contradictions in a world constructed more and more on values of comfort and beauty. In an almost Franciscan way, reminiscent of some Arte Povera actions or artworks, Althamer forces the viewer to look into herself or himself, asserting the position that art's first context is within ourselves—our soul and mind, not yet corrupted by the speed of contemporary reality. What we see is what we want to see. For the now-famous but invisible action he staged for *Manifesta 3* in Ljubljana in 2000, Althamer hired professional actors to perform as "normal" bystanders a few times each day in one of the town's squares. Only after having seen a number of these performances could viewers realize that what they were seeing was not the real life of the city but a set carefully constructed and directed by the artist. The message gradually became clear: what we are looking at is important in terms of what we will make of it in our own lives, in our own private and hidden creative processes. We all are actors, Althamer seems to say, and it is up to us to figure out how we want to change the world through our daily performance called life.
— *Francesco Bonami*

of the show. The marbling on the inside cover also harks back to earlier styles of book design that were most popular in the nineteenth century. In addition, GTF introduced embossed elements such as a printed replica of the Carnegie International medal that was historically awarded to one of the artists (now a cash prize).

One of the defining aspects of the catalogue that was also used in the branding of the exhibition is the brightly colored ribbons or bookmarks stitched into the binding. The fluorescent pink and orange cords inject a splash of color into the publication and stand out against the somber gray cover. This vivid palette is also used inside the book to dominant effect to highlight the names of the artists participating in the exhibition. The ribbons were further exploited at a larger scale within the museum. Translated into large-scale graphics, they were employed as environmental signage in the museum and used on wall texts, banners, and on the Web site. The device worked well in three dimensions and again illustrated GTF's ability to take a single idea as the starting point for a project and adapt it for different uses.

ENVIRONMENTAL GRAPHICS

Graphic design permeates the built environment and is instrumental in defining our relationship to and experience of space. GTF is adept at taking complex systems in two-dimensional form and making them work in three dimensions at the scale of architecture. One of their largest commercial signage and branding projects is part of an ongoing relationship with the UK department store Marks & Spencer. Their graphics for the changing rooms and cafés currently govern the interiors of Marks & Spencer stores. Other projects include developing installations that distill information in eye-catching ways. In 2006 they were invited by the Wellcome Trust to help raise the profile of this medical and scientific research-based charity. One might not realize that the almost eight-foot-high colored neon artworks on view on Euston Road in London are replicas of various protein structures, but they are hard to miss in the windows of Wellcome Trust's headquarters.

Digitopolis
GTF has continued to experiment with new technologies in its print-based work, but in 2000 the firm was given the opportunity to take its ideas from the page to the wall. Invited to collaborate with interior

GTF, graphics for Marks & Spencer, 2005.

GTF, window installations for the Wellcome Trust,
London, 2006.

GTF, exhibition graphics for *Digitopolis*,
Science Museum, London, 2000.
Exhibition design by CassonMann.

DIGITAL HORIZONS

Making long-term predictions about digital technology is a mug's game. But silicon-chip-based computers will reach their maximum power by 2020 if progress continues at the current rate. Will the next generation of computers use DNA, holograms or quantum systems? Or will none of these technologies prove a commercial success?

Where's digital technology going?
Follow the orange tags to glimpse the digital future.

DNA computing

Quantum computing

Computing with light

How does digital technology affect you?

designers CassonMann on the graphics for *Digitopolis*, an exhibition at the Science Museum in London, GTF chose to manipulate electroluminescent technology to create unique signage panels. The printed circuitry glows when an electric current passes through it. This technology is predominantly used to create backlights for alarm clocks and watches, and was a logical design solution for exhibition graphics that needed to stand out in an otherwise dark space, filled with screen-based displays. GTF then hung the signs made from such circuitry panels in transparent cases so that the workings were visible. Although they were primarily functional elements of the exhibition display, the signs were also understood as objects in their own right and an extension of the content of the show.

Alan Fletcher: Fifty years of graphic work (and play)
GTF has always sought to create distinctive design solutions that reveal its personal creative language. Yet more recently GTF was faced with the challenge of designing an exhibition on the work of another graphic designer, famed practitioner Alan Fletcher. The retrospective of Fletcher's work was held at the Design Museum in 2006. Important to GTF's approach was conceiving a design that neither mimicked Fletcher's style nor introduced such a completely foreign concept that it would seem the antithesis of his creative expression. Rather than create a new graphic language, GTF improvised and employed a system of Kee Klamp scaffolding to produce the display structures on which Fletcher's work was presented. Fletcher is known to have used this flexible system to create exhibitions for Pirelli in the 1960s, when he was a principal of the design firm Fletcher/Forbes/Gill. Fletcher had also used Kee Klamp fittings in his home as a structural component of designs for a dining table and stair rails. Neale explained, "In short it was a very Alan material and a general expression of his pragmatic approach."[20] Mirroring GTF's own do-it-yourself attitude, the Kee Klamp system was fitting for the exhibition.

GTF, exhibition design for *Alan Fletcher: Fifty years of graphic work (and play)*, Design Museum, London, 2006.

PRODUCTS

In addition to giving form to ideas through graphic design for books, exhibitions, retail interiors, identities, and marketing campaigns for corporations and non-profit institutions, GTF has also designed a number of products as an extension of the firm's creative output.

The Tate and the Victoria & Albert Museum
Refrigerator magnets for the Tate in London, sold complete with individual "wall labels" for each artwork, and the Perpetual Postcard Calendar, a transparent plastic postcard holder with interchangeable slots that allow users to configure their own visual compositions, are just two of the products GTF has designed for museum stores. In 2006 GTF was commissioned to design a limited-edition mirror for the Victoria & Albert Museum's shop in London. The product was inspired by the V&A's collection of mirrors from around the globe, some dating from more than a thousand years ago. The silhouettes of handheld mirrors, compacts, and ornate dressing table mirrors are hand-silvered onto green-tinted glass. Less precious and more affordable is another limited-edition mirror GTF created for the Tate in 2007, made to represent each frame of two rolls of 36-exposure film.

MeBox
GTF rarely self-generates projects as creative experiments, preferring instead to produce designs in response to a brief. In 2003, however, the firm developed the MeBox storage system as a reaction to the lack of intelligent archival containers. Its integral labeling device is what makes the reinforced cardboard storage boxes unique. The end of each box has a grid of perforated discs that can be pressed out to create initials, numbers, symbols, and even texts. In 2007 GTF launched mini versions of the MeBox for domestic use.

GTF, Perpetual Postcard Calendar for Tate Enterprises, Tate Modern, London, 2001.

MEBOX CUSTOMISA STORAGE SYSTEM DESIGNERS 1 ♥ JUNK
2 3 4 5

Graphic Thought Facility does not take a prescriptive approach to graphic design, but sees the field as a malleable environment for creating inventive and innovative graphic solutions. The firm's designers develop work based on an intuitive process that favors experimentation with and exploration of new materials, production methods, and typography, and an interest in juxtapositions of form, color, shape, texture, image, and text to create unexpected results. Designs that appear ad-hoc or the outcome of chance occurrences are often the consequence of extensive research, development, and ideological imperatives. Formulating core design principles remains the studio's starting point for each assignment. These guidelines evolve systematically over the course of a project as a response to new requirements and ideas, and yet the inherent elements that define a design are consciously retained throughout the process.

Practicality also drives the firm's projects. Often GTF is led by the pragmatic constraints of a project, but its creativity is never eclipsed. Instead, the members enjoy working with restrictions, pushing boundaries to achieve compelling solutions that counter assumptions about the spatial, tactile, and visual qualities of graphic design. GTF is selective about the clients it works with, preferring to keep the studio small in an effort to command work that is in line with the interests of the principals and offers them the possibility of creating a unique graphic language through critical analysis. The design team draws influences from across creative disciplines and incorporates collaboration as an important part of their working process. Joining forces with photographers, illustrators, printers, and other designers, they infuse their output with new ideas and formal qualities.

GTF is part of a generation of design studios that seek relevance to contemporary society through a hands-on approach coupled with knowledge of technology, both old and new, that affords them possibilities for original creative expression. Whether designing exquisitely executed publications or inventive environmental graphics, their work encourages us to take notice of the richness of the world around us.

Previous spread: GTF, MeBox storage system, 2003.
GTF, retail product, Mirror Mirror, for Victoria & Albert Museum, London, 2006.

Notes

1. For more on graphic designers as authors, see Michael Rock, "The Designer as Author," *Eye*, no. 15 (Winter 1994), pp. 26–35.
2. Nick Barley, *Lost and Found: Critical Voices in New British Design* (Birkhauser, 1999), p. 28.
3. Based on interviews with Paul Neale conducted on June 26–27, 2007.
4. Rick Poynor, *Communicate: Independent British Graphic Design since the Sixties* (Yale University Press, 2004), p. 18.
5. Ibid., p. 38.
6. Robert Venturi, *Complexity and Contradiction in Architecture*, 2nd ed. (Architectural Press, 1977), p. 16.
7. Poynor (note 4), p. 39.
8. Claire Catterall, "New Graphic Realism," *Bluprint*, no. 155 (Nov. 1998), p. 34.
9. Barley (note 2), p. 80.
10. Ibid., p. 81.
11. Gareth Williams, *The Furniture Machine: Furniture since 1990* (Victoria & Albert Museum, 2006), p. 20.
12. Paul Greenhalgh, *The Persistence of Craft: The Applied Arts Today* (A. & C. Black, 2002), p. 69.
13. Based on interviews with Paul Neale conducted on June 26–27, 2007.
14. Claire Catterall, *Stealing Beauty: British Design Now*, exh. cat. (London: Institute of Contemporary Arts, 1999), p. 7.
15. Ibid.
16. Alice Twemlow, "The Decriminalisation of Ornament," *Eye*, no.58 (Winter 2005), p. 20.
17. Ibid., p. 21.
18. Personal communication, June 26–27, 2007.
19. John Maeda, *Maeda @ Media* (Thames & Hudson, 2000), p. 145.
20. Personal communication, June 26–27, 2007.